IMPRESSIONIST ART
A CRASH COURSE

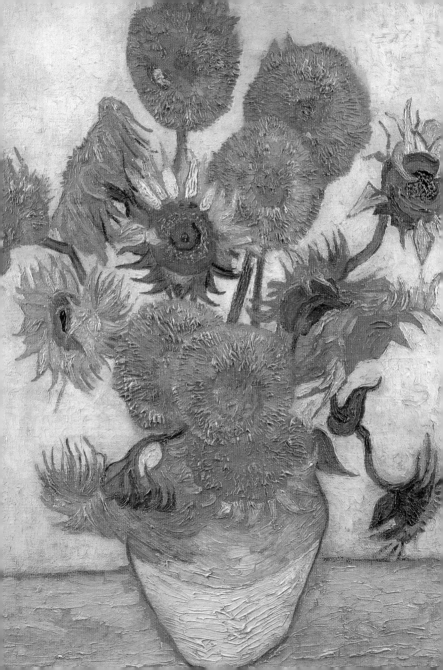

IMPRESSIONIST ART

A CRASH COURSE

DAVID BOYLE

WATSON-GUPTILL
PUBLICATIONS

New York

First published in the United States in 2001
by Watson-Guptill Publications, a division of BPI
Communications, Inc., 770 Broadway,
New York, NY 10003

www.watson-guptill.com

Library of Congress
Control Number: 200188650

ISBN 0-8230-0988-2

This book was conceived, designed,
and produced by
THE IVY PRESS LIMITED
The Old Candlemakers, West Street
Lewes, East Sussex, BN7 2NZ

Art Director: PETER BRIDGEWATER
Editorial Director: STEVE LUCK
Designer: JANE LANAWAY
Editor: GRAPEVINE PUBLISHING SERVICES
DTP Designer: CHRIS LANAWAY
Picture Research: VANESSA FLETCHER
Illustrations: IVAN HISSEY

Printed and bound in China by

Hong Kong Graphics and Printing Ltd.

1 2 3 4 5 6 7 8 9/09 08 07 06 05 04 03 02 01

Contents

Introduction

"A group of five or six maladjusted painters, one of whom is a woman, and all of whom are suffering from an insane ambition, joined together to show their work," wrote the art critic of Le Figaro *during the second Impressionist exhibition in 1876. The public weren't very impressed by their first impressions of Impressionism.*

"They've put their collection of vulgarities on public display without the slightest regard to the drastic

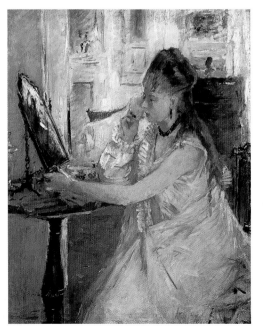

consequences such an exhibit could provoke," continued Le Figaro. *"Yesterday, a young man leaving the exhibit was arrested on Le Peletier Street after he bit passers-by."*

Berthe Morisot, *Young Girl Powdering her Face* (1877): not all Impressionists focused on landscapes.

Timeline
More of a contextual chronology than a timeline, because artists and movements are constantly overlapping. A selected list of major events, inventions, and discoveries happening at the time each artist was popular, to illuminate the type of world they were working in.

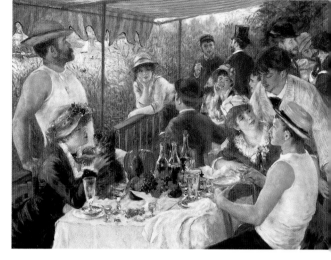

Pierre-Auguste Renoir, *Luncheon of the Boating Party* (1880–1): the quintessential picnic.

Impressionist paintings were so revolutionary that nothing was too far-fetched to accuse them of: sending the public mad, frightening the enemy in battle, causing women to miscarry. Looked at from the point of view of more than a century later, it is hard to understand. Nowadays, when we see Monet's and Renoir's and Degas's pictures on every cookie can, it's hard to imagine them as frighteningly shocking or dangerous.

Yet something about the Impressionists' determination to paint exactly what they saw, to portray ordinary modern life just as it was, and to leave their pictures

TECHNIQUES
Insider knowledge about the new materials and techniques that helped Impressionist artists to create their special effects and change the way color was used in painting.

"unfinished"—as far as the public was concerned—shocked people in a way few artists had ever managed before. They saw Impressionism as lazy and, worse, they saw it as outrageously amoral. It was as if the artists had no moral attitude at all to the prostitutes they were painting—as in many cases they didn't.

It took more than two decades for the public to come to understand a little of what the Impressionist pioneers were trying to do; but once they had done so, they have never wavered in their admiration since. Now those famous pictures —Monet's Waterlilies, Renoir's Umbrellas— are part of modern consciousness. We see them everywhere.

Claude Monet, *The Waterlily Pool* (1904): an early glimpse of Monet's fixation with waterlilies.

How this course works

Each double-page spread is devoted to an artist or group of artists with something in common, and the story proceeds more or less chronologically. On each spread there are some regular features. It won't take you long to figure them out but check the boxes on pages 8-11 for more information.

This Crash Course *takes a closer look at that extraordinary handful of contemporaries and their strange obsessions—from banning black and white from their palettes to painting outside in the wind and the rain—and at their amazing contradictions. Were they Romantics or realists? Were they painting real things or, as Monet put it, painting the air? And what was it that suddenly set light to the artists of Paris in the 1860s and 1870s, that changed painting forever and allowed art to burst forth into its bizarre 20th-century manifestations?*

You may not find the definitive answers to all these questions in the Crash Course. But you'll find enough information to make an excellent first impression.

Edgar Degas, *The Little Dancer of 14 Years* (1879–81): is it Romantic or realist? And why was he always hanging around ballerinas?

Balloon mail
Further snippets providing anecdotal asides or quotations or gossip to fill out the main story.

1757 Benjamin Franklin prints the last edition of *Poor Richard's Almanac*, dedicated to pithy advice like "Early to bed, early to rise, makes a man healthy, wealthy and wise."

1762 Jean-Jacques Rousseau, who first described "the noble savage," declares, "Man is born free, and everywhere he is in chains."

1776 Thomas Jefferson writes the first draft of the American Declaration of Independence, "intended to be an expression of the American mind."

1755~1870

Love and Death
The Romantic Movement

Imagine a sulky adolescent, some time in the second half of the 18th century, waking up one morning with a sense of revulsion at his parent's habits. Those wigs, those sensible, reasonable, reasoned opinions, that pretentious wit. Ugh! Where was their sense of mystery, of fate, of glory? Didn't they realize that we are all animals under the skin, subject to the heights of ecstasy and passion?

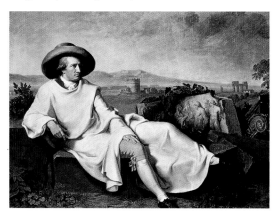

Johann Wolfgang von Goethe adopts a Romantic pose against a Classical backdrop for Johann Heinrich Wilhelm Tischbein's 1787 portrait.

The same generation found itself storming the Bastille in 1789 or reading that revolutionary work of romantic poetry, *Lyrical Ballads* (1798) by *William Wordsworth* (1770–1850) and *Samuel Taylor Coleridge*

That's how the so-called Romantic Movement began. It came from nowhere, but suddenly it was overthrowing everything from conventions to kings.

Actually, of course, those Romantic pioneers woke up and read the poetry of the great German master *Johann Wolfgang von Goethe* (1749–1832), or the political writings of *Tom Paine* (1737–1809), and a strange sense of excitement and possibility took shape.

(1772–1834). Or reveling in the extreme journeys and sexual exploits of *Lord Byron* (1788–1824). "Bliss was it that dawn to be alive/But to be young was very heaven," wrote a breathless Wordsworth as the French Revolution took hold. That was quintessentially Romantic.

"Romantic" was an English term first coined in the late 18th century, and referring mainly to medieval romances. But it was in France where the intellectual

1798 Napoleon invades Egypt but is swiftly kicked out again by British troops.

1843 In Dickens's *A Christmas Carol*, Ebenezer Scrooge is haunted by the ghosts of Christmas Past, Present, and Future.

1870 After nearly two thousand years Rome again becomes the capital of unified Italy.

shape of the Romantic Movement became clear, and it was thanks to the former engraver's apprentice, music teacher, and novelist *Jean Jacques* ROUSSEAU (1712–78). Rousseau argued that human beings in their natural state were far superior to the overcivilized types you find wandering pompously around the streets of Paris. Since he lived in successive European capital cities, we can only assume that he wasn't too concerned about his personal popularity.

Literature and art became more passionate and emotional, with the French embracing *Napoleon* BONAPARTE (1769–1821)—a humble Corsican army officer before the Revolution—as the archetypal Romantic hero. It all seems a long way from the Impressionists.

> ### NAMES IN THE FRAME
> *The French Romantic painters latched onto Napoleon at an early stage, inspired by works like the battle paintings of* **Jacques-Louis David** *(1748–1825), and their enthusiasm reached its height with a series of pictures by* **Théodore Géricault** *(1791–1824) showing the depths of human suffering. Suffering is, after all, as Romantic as glory. His most famous painting,* Raft of the Medusa *(1818–19), portrays the survivors of the ill-fated wreck in various stages of starving to death.*
> *The public loved it.*

But along with all the rest of the Romantic baggage came a passion for landscapes, for being in the open air, for ordinary simple people toiling away in fields, and—above all—a sense that what so-called "civilized" people think they see isn't the truth at all. It was this obsession with observing the truth and painting things as they really are—as impressions—that would shake the Impressionist pioneers a few decades later.

Thinking and feeling

Rousseau declared that we should honor what he called "the noble savage," who was in touch with his instincts and passions. It was a deliberate clash with the watchwords of the old-fashioned Classical age—"I think therefore I am," coined by another Frenchman, philosopher René Descartes (1596–1650). For the Romantics, it was the other way around: "I felt before I thought," proclaimed Rousseau.

Napoleon Bonaparte, Romantic hero, fighting the Austrians. By Antoine-Jean Gros (1791).

1768–71 Captain James Cook sails around New Zealand, proving that it is an island.

1775 The Hindu Maratha princes from the south of India begin the first war with British settlers.

1784 Shrapnel shells are invented containing small spherical shots. A time fuse causes them to explode near opposing troops, raining down high-velocity debris.

1766~1828

Blurred Brutality

Goya

Goya's unusual career choices.

If you start looking too far for the roots of Impressionism, you find yourself going back to the origins of art, beyond the Renaissance, all the way to the cave paintings. But there was a moment when the Romantic Movement and realism first seemed to come together, in the paintings of the Spanish artist Francisco GOYA (1746–1828). He had a pretty wild and varied career, living through the horrors of the Peninsular War and emerging on the other side as a court painter in Madrid, but by the end of his life—in exile in France—you can see the very first stirrings of Impressionism at work.

Nightmare!
Just as Manet and the later Impressionists would do, Goya combined wild Romanticism and terrifying realism. His famously nightmarish "black" paintings represented a whole new approach to art: he was claiming the right to paint his innermost thoughts. Half a century later, the Impressionists would acknowledge that his work was an important forerunner to theirs.

Francisco Goya, *Third of May 1808* (1814): compare to Manet's version of the same scene on page 65.

I t wasn't so much his so-called "black paintings," the nightmarish monsters, or the powerful pictures of the brutality of war: check out his two paintings *Second of May 1808* and *Third of May 1808* now in the Prado in Madrid. Nor was it so much the strange way in which he could paint for both sides simultaneously: he worked for the Bourbons as well as the liberals, and he painted frescos inside churches at the same time as he was producing vicious attacks on

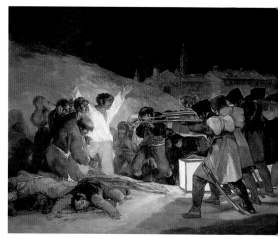

1793 Louis XIV and Marie Antoinette are guillotined in France as revolutionary fervor goes berserk.

1803 France sells the state of Louisiana to the US for $15 million. Rumor is that they wanted rid of it anyway, because the people were too ungovernable.

1821-24 John Keats dies in Rome of tuberculosis; 1822 Shelley drowns in the Bay of Spezia; and 1824 Lord Byron dies of fever while fighting for Greek nationalism.

the excesses of the Catholic Church. But there was something about his bright colors and revolutionary smudged look that made him the forerunner of Manet half a century later (*see page* 40).

There seems to be something almost unfinished about his work. Have a look, for example, at the frescos on the cupola of S. Antonio de la Florida in Madrid, painted with sponges—a technique that involved sort of wiping the color on. And Goya was also one of the first painters who tried to paint the moment—exactly as it was, not in the way conventional art had always portrayed it. His pictures of children playing have a life and immediacy about them that has no equivalent until much later, when Renoir began to paint his party scenes (*see page* 78). Above all, you can see it in his portraits.

Why did the Bourbon royal family of Spain carry on asking Goya to paint them, when he insisted on portraying them as they really were, warts and all? The images that have been handed down to posterity show them looking like brutal butchers, with unpleasant oafish expressions. And below their faces Goya just gives the impression of glittering gold braid and medals, rather than faithfully recording the details of their finery. Nobody had tried anything of the kind before.

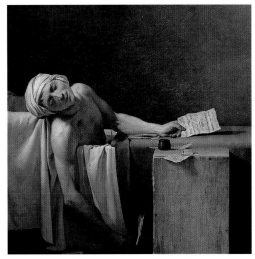

Jacques-Louis David, *The Death of Marat* (1793): tasteful, Romantic, and posed. Painted soon after Marat was stabbed by Charlotte Corday.

NAMES IN THE FRAME

In Goya's day, the old guard were still painting in the conventional Neo-classical mold, even if they were trying to do so in Romantic ways. Take Goya's French contemporary **David** *(see page 13), who had become almost the artist by special appointment to the French Revolution. His* The Death of Marat *(1793) is shorn of all other detail except the noble body of the revolutionary leader lying murdered in his bath, with a tasteful flecking of blood. It was austere and about as un-Impressionist as it was possible to be.*

1804 William Blake writes the poem "Jerusalem"; it is not until the First World War that the famous tune is added and it becomes a patriotic anthem.

1815 Napoleon is exiled to St. Helena after defeat at the Battle of Waterloo; maybe he should have listened to his own advice that you shouldn't fight the same enemy too often or they learn your tactics.

1829 Robert Peel founds the Metropolitan Police Force in London. The British "bobby" is armed only with a top hat and a truncheon.

1803~1837
Hay-waining
Constable

Flat country

Like so many members of the Romantic Movement in England, Constable found the Lake District inspirational. He went there in 1806, just as his contemporary William Wordsworth (see page 12) was scribbling away in a small cottage in Grasmere. But he was at his best when the landscape was decidedly flat. "These scenes made me a painter," he said of the Suffolk countryside. It was this, and staring long and hard at Dutch 17th-century landscape pictures, that set him on the road to stardom. His studies are even more Impressionistic: check out his *Study of Tree Trunks* (c. 1821) at the Victoria & Albert Museum in London.

Whether or not you believe that the roots of Impressionism lie in the English countryside depends on the country of your birth. But there's no doubt that one of the ancestors of the whole business was the English landscape painter John CONSTABLE (1776–1837), whose bucolic scenes of millponds and hayfields can now be seen on posters, dish towels, and cookie tins all over the world.

Constable had been happily painting away across the Channel for more than two decades when his famous *The Hay-wain* (1821) first went on show at the Salon in Paris in 1824. It may have been just a picture of a farm worker inexplicably choosing to travel in his cart along a shallow river rather than on the road, but its bright colors and enormous sky took the French art world by storm. Constable had been influenced by the French landscape artists *Nicolas POUSSIN* (1592–1665) and *Claude LORRAINE* (1600–82), so maybe the credit all evens out in the end.

1830 The lawn mower is invented by Edwin Budding in Ipswich, England.

1834 The British Houses of Parliament burn down and Charles Barry wins the competition to design the replacement.

1836 Parties of Boers begin their Great Trek from the Cape of Good Hope to settle in the South African interior, irked by liberal British policies toward black Africans.

English prints and travel books were popular in Paris in those days, but Constable provided something else. It soon became clear that the reason his greens were so vivid was because he didn't just paint the grass one uniform light green shade. He put in lots of tiny brushstrokes in separate shades of green, right next to each other. That is, after all, what we see when we look at a field.

But then the real scenes we see—and this would become the central Impressionist idea—aren't quite what we think we see. In reality, they are a mass of different colors

and impressions, of light and dark, sunlight and shadow—what the old Italian Renaissance pioneers called *chiaroscuro*. It was difficult to capture on canvas. "The Chiaroscuro of nature in the dews, breezes, bloom and freshness," Constable called it, "not one of which has yet been perfected on the canvas by any painter in the world."

English art isn't often in such vogue in France, but Constable had raised an issue that appealed to French thinkers and artists. "Remember that light and shadow never stand still," he often said. If so, how do you portray them realistically on something that by definition stands still?

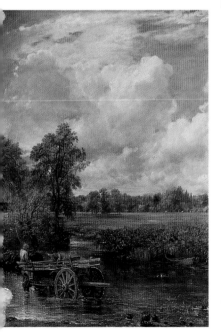

John Constable, *The Hay-wain* (1821): was this the first Impressionist painting? It certainly got them thinking across the Channel.

1819 Sir Thomas Stamford Raffles founds the city of Singapore; a famous hotel will be opened there in his honor in 1886.

1825 Russian officers known as the Decembrists mutiny, demanding a constitutional monarchy; most are executed.

1836 Ralph Waldo Emerson writes *Nature*, in which he explains his transcendentalist philosophy and says "There is no object so foul that intense light will not make it beautiful."

1819~1863

Blood and Iron
Delacroix and Turner

TECHNIQUES
Delacroix banned earth shades like dull reds and browns from his palette, preferring to use his colors pure and unmuddied. Instead of mixing colors with black to indicate shadows, he chose alternative colors. He also came up with a revolutionary idea of bringing light into the painting by mixing all his colors with white. Seems pretty obvious with hindsight.

The trouble is, there was more than one kind of Romantic. There was the sort that watched nature and let it wash right over them, and there was a much more dangerous kind. By the middle of the 19th century, there were suddenly a lot more of the latter, and they were very overexcited too. These were revolutionaries like Giuseppe GARIBALDI (1807–82), those who hankered back to great nationalists like Napoleon, or those that looked forward to new nations of the future like Otto von Bismarck (1815–98; motto: "Blood and iron"). Being a Romantic could be a very military business.

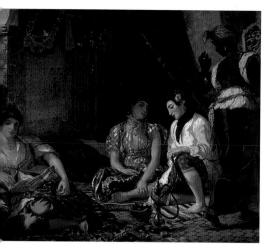

Eugène Delacroix, *Femmes d'Algers* (1833–4). His paintings were typically full of color, intrigue, and romance. What were they talking about?

The great French Romantic painter *Eugène DELACROIX* (1798–1863) was a bit of both. He couldn't abide the dull study of ancient Romans and Greeks, and far preferred color and imagination to careful drawings with sharp outlines. But in 1832, searching for something more interesting to paint than the conventional naked poses (yawn!), he dashed off to North Africa and immersed himself in the color and excitement of Arab life. Delacroix's canvases were filled with the heat of the moment, battling horses, whirling dervishes, colored robes. Check out the riot of color in his work at your local museum.

1842 The new two-wheeled bicycle, designed by Kirkpatrick Macmillan, wins a race with a post carriage.

1861 William Morris founds a decorating firm with Rossetti and Burne-Jones to make stained glass, carpeting, carvings and metalwork.

1863 The world's first subway is opened in London. What will they think of next?

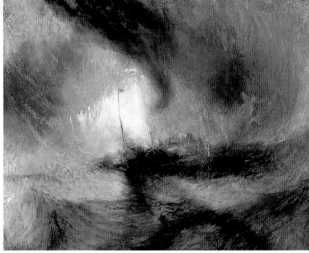

The French artistic establishment hated it. They were furious at his rejection of Classical tradition, and even more enraged by the adulation he was receiving from younger artists. For another quarter of a century they refused him election to their sacred Institute and battled to keep his paintings out of the Salon—the pinnacle of achievement for a French artist. Despite all the sound and fury, Delacroix was still the artist who first acclaimed Constable's landscapes when they arrived in Paris (*see page 16*).

All the Impressionists were influenced by Delacroix—not so much by the Arabs and the horses, but by his pure bright colors. "It is well if the brushstrokes are not actually fused," he wrote. "They fuse naturally at a certain distance by the law of sympathy that has associated them. The color thus gains in energy and freshness." In his painting *Femmes d'Algers* (1833–4) he produced the impression of gray, not by using gray paint but by juxtaposing patches of red and green. Monet and Bazille watched Delacroix at work in the street below their apartment just before he died in 1863, just as their first impressionistic ideas were coming together.

Joseph Mallord William Turner, *Steamer in a Snowstorm* (1842): another pioneering impression by an artist who was dead before the Impressionists had picked up their paintbrushes.

NAMES IN THE FRAME

Delacroix's English equivalent was **J. M. W. Turner** *(1775–1851), the son of a Covent Garden barber. Turner experimented with the idea of colored light—or, as Constable put it, "tinted steam." His paintings showed machines overwhelmed by the forces of nature—see his extraordinary* Steamer in a Snowstorm *(1842), which was more impressionistic than almost anything painted before. His landscapes glowed with light, but the establishment didn't like those any more than they liked Delacroix: "Pictures of nothing, and very like," wrote one critic.*

1827 New Orleans has its first Mardi Gras celebration, and people have been celebrating ever since.

1840 Seabird droppings are imported into England from South America to fertilize the soil.

1849 Japanese *ukiyoe* painter Katsushika Hokusai dies at the age of 89. He has changed his pen name 33 times during his career, giving the old name each time to a student.

1827~1875

The Peasants' Revolt
Corot and the Barbizon School

The joys of watching others at work.

As the political situation overheated across Europe in 1848—the so-called Year of Revolutions—a group of French artists escaped to the village of Barbizon, in the forest of Fontainebleau, in search of something a little calmer. They were all followers of John Constable (see pages 16-17) in their own way and, led by Jean-François MILLET (1814–75), they began to turn to the locals for their subject matter.

It had traditionally been a bit of a joke, right back to the time of *Pieter BRUEGHEL* (c. 1525/30–1569), but the Barbizon artists saw peasants in paintings differently. They just wanted to copy real life as truthfully as possible and—this is what made them unusual—to do so out of doors. Soon artists like Millet, *Theodore ROUSSEAU* (1812–67), and *Charles DAUBIGNY* (1817–78) were busily painting the countryside, along with its inhabitants. Check out Millet's *The Gleaners* (1857). It isn't Romantic in the sense that there was anything special or heroic about the harvesters; it's Romantic because they were rural, ordinary and real.

As usual, the artistic establishment didn't like it much. "This is the painting of democrats," said Count Nieuwerkerke, the Superintendent of Fine Arts in Paris, "of those who don't change their linen."

Jean-François Millet, *The Gleaners* (1857): a bit too democratic for comfort with so many revolutions going on.

1858 Mary Ann Evans publishes her first novel under the pen name George Eliot, which she will keep for the rest of her career.

1869 The Suez Canal opens, shortening the sea route from Europe to India by 4,000 miles (6,440km).

1875 A machine is invented to strip the kernels from corn on the cob, leading to widespread canning of the product.

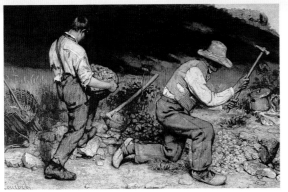

Gustave Courbet, *The Stonebreakers* (1849): appalling poverty painted in the aftermath of revolution.

Back to the future

Renoir, Pissarro, and Cézanne would all be fascinated by Courbet's work and each tried to imitate him. They even experimented with using the same sort of palette knife. They also learned from his determination to hit back at the Salon when it refused to hang his paintings by setting up his own private exhibitions in 1855 and 1857. But they didn't learn from the fate of those who go it alone. Courbet made himself a serious target for the critics, who were only too pleased to cut arrogant artists down to size.

Daubigny was even attacked for his "impressions." In a generation's time, it would be a rallying cry.

At the same time, their revolutionary colleague *Gustave COURBET* (1819–77) was paving the way for Impressionism with his "representation of real and concrete things"—sometimes executed with a very real palette knife rather than a brush. He

NAMES IN THE FRAME

The other great forerunner of Impressionism was the landscape painter **Jean-Baptiste-Camille Corot** *(1796–1875), who developed the idea of painting on the spot, in natural light, during his visit to Rome in 1825. "Never abandon it," Corot said about an artist's direct impressions of a scene. See how he deals with sunlight in* Le Pont de Narni *(1826). He taught Pissarro (see page 36) and Morisot (see page 60), but by the end of his life referred to the Impressionists in derogatory fashion as "that gang."*

extended the scope to cover terrible poverty in his painting *The Stonebreakers* (1849), later destroyed during the Allied bombing of Dresden in 1945, and he spent his time wandering around with easel, paints and palette knife looking for interesting subjects to paint.

Courbet destroyed his career in France by flirting with the Commune in 1871 (*see page 65*) and ending up in prison, debt and exile for the part he played destroying the Napoleon Column in the Place Vendôme. By 1873 he was forced to escape to Switzerland, where he died, still trying to pay off the fine imposed on him by the French courts and just a little too early to appreciate the Impressionist revolution he had helped to create.

1828 Schubert's *Fantasy in F Minor for Piano Four Hands* is performed shortly before he dies of typhus, leaving his *Symphony in B Major* unfinished.

1835 Madame Tussaud's Waxworks in London contains the guillotine that killed 22,000 people during the French Revolution.

1841 UK travel agent Thomas Cook persuades railroad companies to sell inexpensive tickets so people can have vacations in Blackpool.

1828~1862

Sing a Rainbow
The physics of light

Was it really a coincidence? Just as the Impressionist pioneers were growing up, there was a sudden breakthrough in the science of colors and the understanding of what we see. Three centuries earlier, in 1666— the year of the Great Fire of London—the fearsome scientist Sir Isaac Newton (1642–1727) had discovered that white light is actually made up of lots of different colors. In fact, he demonstrated that it can be split into a rainbow by shining it through a prism.

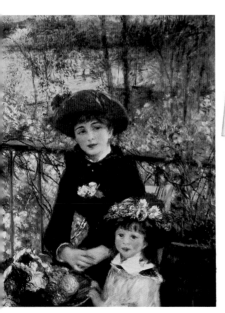

Pierre-Auguste Renoir, *Two Sisters* (otherwise known as *On the Terrace*) (1881). He stuck closely to the primary colors.

TECHNIQUES

Renoir (*see page* 46) learned all about color while training as a painter of porcelain, and as an artist he stuck rigidly to five colors on his palette—lead white, vermilion, emerald green, Naples yellow, and cobalt blue. He generally painted on a white background to bring out the light, and used the law of complementary colors to make them both seem brighter. See, for example, the greens juxtaposed next to the reds in *Two Sisters* (1881).

It was clear to everyone that all colors were actually based on just these three —red, yellow, and blue—which became known as the primary colors. (This book is printed from four plates—black, blue, yellow and red—and all the color pictures are composed from varying percentages of these plus white.)

Then along came the chemist *Eugène* CHEVREUL (1786–1889)—the incredibly long-lived expert in margarine, oils, and fats, who devoted the middle years of his life to the science of colors. In his book

1856 The first synthetic dye is a mauve color; Queen Victoria wears a dress dyed with it.

1860 Charles Darwin writes: "I cannot believe that a beneficent and omnipotent God would have designedly created the *Ichneumonidae* with the express intention of feeding within the living bodies of caterpillars, or that a cat should play with mice."

1862 In the US, the Homestead Act offers each Mid-West citizen 160 acres of land for a small sum of money as long as they live on it for 5 years.

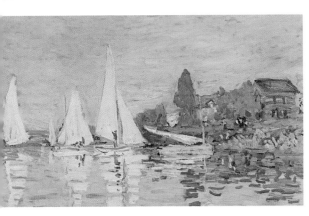

Claude Monet, *Regatta at Argenteuil* (1872): see how the blues and oranges are placed next to each other to enhance the overall effect.

They looked different according to the other colors around them. It was a visual kind of relativity—just as the same scene might look completely different at different times of the day, in different

On the Law of Simultaneous Contrast of Colors (1839) he claimed that each color has an opposite. Every color modifies the way we see the one next to it, and colors are at their most intense when they are seen next to their opposite or "complementary" color. He had discovered the phenomenon while he was experimenting with dyeing techniques, and realized that colors seemed brighter or duller according to the color next to them.

The early Impressionists would learn from him. Three decades later they were juxtaposing complementary colors in their paintings—like red with green or blue with orange. See, for example, Monet's *Regatta at Argenteuil* (1872), where the reflections on the lake are painted in orange to produce greater contrast.

Chevreul's theories became the basis for Impressionism and its related ideas, Pointillism and Divisionism (*see page* 92). The point was that colors weren't fixed.

lights and in different seasons. Monet (*see page* 120) would later paint lots of pictures of the same place at different times, with the date and time marked on the back of the canvas, as part of his investigation into the properties of color and light.

NAMES IN THE FRAME

Chevreul started work as a chemist at 17 and took charge of the laboratory at the College of France just three years later. His first job as professor was in the early years of the century, when he was also put in charge of the dyeing department at the Gobelins tapestry factory. He later became director of the Museum of Natural History and enjoyed the title "le doyen des etudiants de France," but from 1828 to 1864 colors were his obsession. On his 100th birthday, the nation struck a medal in his honor, with the head of the Republic, an eagle, and a thunderbolt—all frighteningly Romantic motifs.

1830 The first edition of James Audubon's *Birds of America* is published, featuring his meticulous watercolors.

1836 The Arc de Triomphe, the world's largest triumphal arch, is completed in Paris.

1841 The world's first advertising agency is started by a Philadelphia businessman who sells advertising space in newspapers at a premium price.

1830~1857

Only If I Can Touch It

The new naturalism

It's one of the peculiarities of intellectual and artistic movements that just as they're settling down at the easel, their philosophy suddenly

looks different. This was the case with the French Romantics in the middle of the 19th century. What started as a determination to let nature flow over them became a determination to see and paint everything exactly as it was— to stare unflinchingly at the world, even if it was ugly, and reproduce it, impressions and all. Or, of course, to immortalize unsuspecting gangs of peasants who thought they were just going out for a day's harvesting.

The philosopher David Hume: an early "naturalist."

A s for the Impressionists, the world was a rapidly changing place of fleeting experiences. They had to be on the spot. This was the artistic movement known as "naturalism." It was influenced by so-called "empirical" philosophers like *David Hume* (1711–76)—people who believed the only important evidence was what we could see, touch, taste, smell, or hear.

It was backed up by the thinking of the new utilitarians, like *Jeremy Bentham* (1748–1832)—given a standing ovation by French *parlement*—who believed that life was just about being useful.

NAMES IN THE FRAME

The philosopher most responsible for naturalism was **Auguste Comte** *(1798–1857), the founder of sociology— itself a kind of Impressionist method of looking at the world by counting everything. Comte founded the "positivist" school of philosophy, which rejected God and argued that science and the senses are the only source of knowledge. He committed all his ideas to print in the six-volume work* Course of Positive Philosophy *(1830–42). The modern world had just arrived.*

Comte was busy counting.

1849 American philanthropist Gail Borden invents a "meat biscuit" as a portable snack for friends who are going on a long journey.

1854 There are riots in London's Hyde Park after pubs are forced to close on Sundays. Rioters break the windows of passing carriages.

1857 Count Agoston Haraszthy de Moksa plants Tokay, Zinfandel, and Shiras grape varieties from his native Hungary in Buena Vista, California, and the grape and wine industries are established there.

Later on, it was French writers like Zola (*see page* 70) who kept the ball rolling, with novels like *Thérèse Raquin* (1867). He was determined to portray life as it really was—and was soon facing allegations of obscenity as a result. Zola's world wasn't the same as the bucolic dreams of painters like Rousseau, but the two strands came together to inspire the early Impressionists.

It was a disappointing moment in France. The 1848 revolution had failed. Louis Napoleon had seized power (*see page* 32), the dreams of democrats everywhere were being betrayed. Utopias didn't seem to work very well—so the intelligentsia fell back on observable facts. And when they found themselves defending Courbet, they realized they were actually defending "naturalism." "I am not only a socialist," wrote the inflammatory Courbet, "But also a democrat and a republican, in a word, a partisan of revolution and, above all, a realist, that is the sincere friend of real truth."

The doctor's wife

The trouble is, the public didn't understand. They didn't like it either, but they did consider it titillation. Especially when Gustave Flaubert (1821–80) burst onto the scene with his first and most shocking novel *Madame Bovary* (1857), describing the tragedy of the adulteries of the romantic wife of the local doctor. The characters were "naturalistic," deeply dull, and mediocre. He and his publishers were immediately prosecuted for immorality and, although they were acquitted, a cloud hung over Flaubert and his works for the rest of his life.

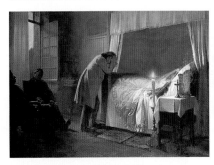

Tragic but realistic: the death bed of Madame Bovary. Painted by Alvert-Auguste Fourier (1857).

Whatever happened to beauty? asked the critics? What about idealism? And spirituality? The idea that pictures should be delightful? They accused Courbet of "wallowing in filth."

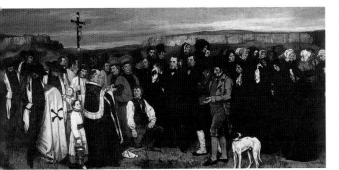

Gustave Courbet, *French Burial at Ornans* (1850–1): painting people as they really were.

1832 The US Army abolishes soldiers' daily liquor ration.

1839 Madeleine Usher is buried alive in Edgar Allen Poe's *Fall of the House of Usher*.

1846 A portable ice cream freezer is invented in New Jersey. It is operated by cranking it by hand.

1832~1880

Picnic Hampers
Artists do it outside

If there was one thing the Impressionists shared—as we'll see, there wasn't much—it was an enthusiasm for painting in the open air. Changes in light were the key to a painting, but how could you possibly capture them in a studio? And "capturing" impressions was the name of the game.

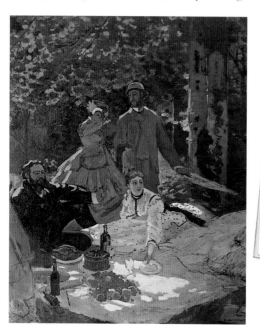

TECHNIQUES

Until the 1840s, an artist who wanted to paint out of doors in oils had to take their little pouches of paints, made out of pigs' bladders, prick them open with a tack and hope they didn't dry out too quickly. Usually they did. Then along came paints in metal tubes that you could squeeze. It was the kind of revolution that the Renaissance painters had experienced when they switched to using oil paints for their frescos and could suddenly slow down because they didn't have to race to finish before their plaster dried out.

Claude Monet, *Le Déjeuner sur l'Herbe* (The Picnic) (1865). People were starting to take pleasure out of doors. (For Manet's famous picnic, *see pages 54–5*.)

Painting outdoors was nothing new. The Romantic Movement, in which they were all steeped, believed in nothing better than a good immersion in nature. Naturalism dictated that you had to be there on the spot to paint the truth, and the Barbizon School of Millet and Rousseau had been hanging around villages painting peasants for decades.

But for them, the idea was to make a rapid sketch in oils in the open air and then take it back to the studio to work it up into

1857 Millet paints *The Gleaners*, one of his genre paintings of people working outdoors.

1864 Englishman W.G. Grace begins the cricketing career that will see him win 54,904 runs, 126 centuries, and 877 catches.

1880 The first British telephone directory is issued in London. It lists 255 names.

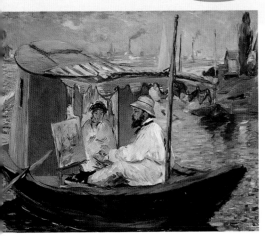

Edouard Manet, *The Barge* (1874): his impression of Monet painting outside in his studio boat. The Impressionists liked painting each other.

people in the picture, while the old Barbizons had just wanted to get in touch with nature. The Impressionists were fascinated by nature too, but they were city people at heart. Even so, that didn't stop Monet acquiring a studio boat with a striped yellow awning while he was living by the Seine River in the 1870s, and mooring it in the middle of local yachts to get a more immediate impression of them. By that time, the railroads that had brought Fontainebleau to within an hour of Paris were speeding a new generation into the countryside with easel and canvas and picnic hamper. This was the generation that discovered picnicking.

a finished piece. The Barbizon painter Daubigny (*see page 20*) was one of the first who believed that his outdoor sketches were finished works. The critics accused him of being "satisfied with an impression."

There are photographs of the great landscape artist Corot (*see page 20*) painting under a big umbrella, but it was Boudin and Jongkind (*see* box) who persuaded Monet (*see page 46*) to pack up his kit and paint outside. From 1863, Monet led his friends on expeditions to the forest of Fontainebleau—and that's where Impressionist landscape painting began to take shape (*see page 62*).

But Impressionist landscapes were different. They weren't as fussy as those of the previous generations, and they usually included

NAMES IN THE FRAME

It was the amazing skies and seascapes of two artist friends of Monet's that set the whole ball rolling. Dutch painter **Johan Barthold Jongkind** *(1819–91) never painted in oils out of doors, but the effects he tried to create were similar. He even painted a series of pictures of Notre Dame de Paris in different lights. See his* Entrance of the Port of Honfleur *(1864). Honfleur was also the birthplace of his friend* **Eugène Boudin** *(1824–98), a pal of Corot's—whose skies fill most of the canvas. Jongkind is "quite crazy," Monet told Boudin in 1860, without having met him. But alas, his impression was right. Like Van Gogh, Jongkind died insane.*

1838 Coal and wood are the world's favorite cooking fuels but the Inuit use whale blubber oil, Arab nomads use chips of camel dung, and Native Americans use chips of buffalo dung.

1850 The Greek government are forced to pay compensation to a very dodgy character called Don Pacifico who claims that he has lost documents worth $33,000 in a fire in Athens.

1854 *The Times* reports that in the Battle of Balaclava, 387 British soldiers and 520 horses are killed, wounded, or reported missing.

1838~1888

Watch the Birdy!
The arrival of photography

When Louis Daguerre popularized the idea of photography with his first photo in 1839, it was bound to change the visual arts. It's just that it took rather a long time to filter through to painting. The Impressionists would embrace photography wholeheartedly but, before their emergence, artists mainly used photographs to keep a scene in front of them once they were back in the studio.

Corot (*see page 20*) took photos of whatever scene he was painting back to his studio. Manet based his portrait of the poet Baudelaire (1869, *see page 70*) on a photograph of him by Nadar (*see box*). So much for Impressionist spontaneity—Monet owned as many as four cameras, and based his famous painting *Women in the Garden* (1866-7)—rejected by the Salon—on a series of photographs he had taken in the garden of his friend Bazille (*see page 47*). Monet also made copious use of photographs when he came to paint his multiple views of Rouen Cathedral (*see page 120*), despite his role as the great prophet of outdoor painting.

Flux
Reviewing Monet's *Boulevard des Capucines* in 1874, one critic wrote: "Never has the amazing animation of the public thoroughfare, the antlike swarming of the crowd on the pavement and the vehicles on the roadway, nor the elusive, fleeting nature and instantaneity of movement, been caught in its incredible flux and fixed as in this extraordinary picture." Instantaneity is not a word we use much these days, but for the Impressionists it summed up the novel experience of seeing moving life stilled for a second. For the Victorians, photographs gave a completely new view of life.

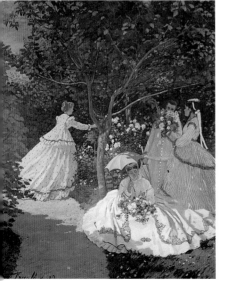

Claude Monet, *Women in the Garden* (1867): constructed using a series of photographs. The exposure time was so long that any movement would cause a blurred result in the photograph.

1870 The bustle is coming into fashion for women. Corsets squeeze the waist into agonizing proportions and dresses trail up to a yard behind the wearer.

1888 George Eastman produces the first Kodak camera with the slogan, "You press the button, we do the rest."

Claude Monet, *The Boulevard des Capucines* (1873): critics were excited by the way he captured the "instantaneity" of the moment.

But the real power of photography was that it fed into the obsession of the Impressionist artists with realism and what the eye really saw. Unlike your average art critic, the camera, they say, never lies. It picks up the blurred impressionistic background in a busy street. If half a figure is outside the frame, the photo shows it that way. There's none of the careful arrangement artists were supposed to make. This was the stuff of Impressionism—immediacy. Degas (*see page 58*) used photography and referred to it as "magical instantaneity."

When portable cameras and snapshots started appearing on the market in 1888, the influence of photography advanced another notch. But in the 1860s and 1870s it was the aerial photographs of Paris (*see box*), and the blurred brown and white pictures of busy streets that fired the imagination of the Impressionist artists. For the first time in history, you could take a scene home. One thing was for sure—art would never be the same again.

NAMES IN THE FRAME

*The pioneering photographer Gaspard-Felix Tournachon, better known as **Nadar** (1820–1910), met the Impressionists at the Café Guerbois (see page 56). In 1863, he thrilled the world of photography by going up in a balloon and taking the first aerial views of Paris. The police weren't keen on him, though, describing him as "one of those dangerous characters who spread highly subversive doctrines in the Latin Quarter."*

Nadar shoots Paris from the air.

1851 The 108-ft (3-m) high Crystal Palace, built to house London's Great Exhibition, uses one third of Britain's entire glass output for the year.

1862 Dante Gabriel Rossetti's wife dies of an overdose of the laudanum she's been taking to quell the pain of tuberculosis.

1869 Hailstones break the glass roof of the arcade connecting the Piazza del Duomo and the Piazza della Scala in Milan.

1851~1890

People Who Live in Glass Houses
The new architecture

It probably wasn't a coincidence that just as the young Impressionists were growing up, dreaming of dappled light on picnic scenes, a new kind of building suddenly appeared that was filled with dappled light. Can you imagine a whole building made out of glass? We can these days, of course, but the concept of living in a greenhouse was brand new when the Impressionists were entering their teens. Suddenly houses didn't have to be dark, shadowy spaces any more.

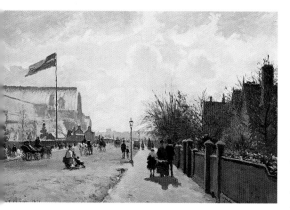

Camille Pissarro, *The Crystal Palace, London* (1871). Pissarro lived across the road from it during the Franco-Prussian War, when he was in exile from occupied Paris.

was a huge success, and the most profitable exhibition in history, but it was the building—moved shortly after to Sydenham, where it was painted by Pissarro (1871)—that was the real wonder of the world. It still would be if it hadn't burned down in mysterious circumstances in 1936.

A well-known example was the Crystal Palace, a massive 410ft- (125m-) long structure, built for the Great Exhibition in London in 1851 by the landscape gardener Joseph Paxton (*see* box). It was one of the first buildings not built primarily of bricks or wood, but with massive iron girders—along the lines of the Palm House at the Royal Botanic Gardens in Kew (1845-7). The Great Exhibition

It was a time when engineering and architecture were converging. Great iron bridges were beginning to forge their way across rivers, the new railroads were forcing their way through the outskirts of cities, and great cathedrals of arches were being built for new railroad stations on both sides of the Channel. "Glass and iron": a more civilized slogan than: "Blood and iron."

1873 At a public banquet in Australia, chicken, fish, and meat that have been frozen for six months are eaten.

1881 Russian Jews flee the systematic pogroms after Alexander III becomes czar.

1889 Gilbert and Sullivan disagree about a carpet in the Savoy Theater during the run of *The Gondoliers*, and they don't speak for many years.

Buildings got lighter throughout the lifetimes of the Impressionists, and by the time they were middle-aged, electric light was making their homes even brighter. Factories were also brighter, because electricity had banished all those vast moving belts that used to operate the machinery and obscure the light.

NAMES IN THE FRAME

Sir Joseph Paxton *(1801–65) was the greenhouse designer and horticulturalist employed by the Duke of Devonshire at Chatsworth House before he turned his attention to building the Crystal Palace, then the biggest prefabricated structure in the world. It was simple and light, but its contents were still rather overwrought: the Impressionist concern for simplicity hadn't yet filtered down. The young* **William Morris** *(1834–96), future leader of the Arts and Crafts movement, was so horrified by the Victorian overdecoration that he rushed outside and threw up.*

The whole process culminated in the Paris Exhibition of 1889, which produced the world's tallest structure and the one with the widest span. The widest was the Galerie des Machines: the tallest was the Eiffel Tower—984ft (300m) high, made with 7,000 tons of wrought iron, and taking glass buildings to their logical conclusion by leaving out the glass altogether. By the time the Impressionists were middle-aged, it would tower over their city.

Eiffel

Gustave Eiffel (1832–1923) was a man who straddled two worlds. The railroad bridge he designed in Bordeaux in 1858 was so successful that he set up his own company, which helped to cast the Statue of Liberty—a present to the Americans on the 100th anniversary of US independance—and designed the Eiffel Tower a century after the French Revolution. Then, having glimpsed the future of architecture, he gave it all up to study aerodynamics. He lived to see the results of his work in the massive growth of rail and air travel in the early 20th century.

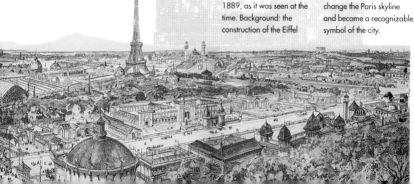

The Paris Exhibition in 1889, as it was seen at the time. Background: the construction of the Eiffel Tower in 1887, set to change the Paris skyline and become a recognizable symbol of the city.

1856 Frenchman Pierre Pellier starts California's prune industry when he plants an Agen plum tree.

1861 French illustrator Gustave Doré produces a woodcut to illustrate Dante's *Inferno*.

1872 The Brasserie Lipp opens on the Boulevard Saint-Germain-de Pres, named after a famous restaurant in Strasbourg.

1852~1914

Capital of Art
The new Paris

Paris in the second half of the 19th century may not have been the most powerful city on earth, or the safest, or the most docile—but it was slowly becoming the capital of art and one of the most exciting and stunningly beautiful cities in the world.

Great architecture and chic cafés.

The last emperor

Napoleon III (1808–1873) was an uncategorizable emperor, and in the end rather a tragic figure—and not just because of his striking resemblance to Baron Munchausen. The nephew of Napoleon Bonaparte, he managed to win election as president of the Second Republic after the chaos of 1848—then seized power in a coup and proclaimed himself emperor in 1852. His naïve and romantic foreign policy tempted him to declare war on the Prussians in 1870, with disastrous results (*see page* 64). He died in exile in England, and his eldest son died fighting for the British in the Zulu Wars.

It was one of those issues the Impressionists discussed in cafés half the night (*see page* 56): were the new boulevards and squares tasteful or not? Wasn't there something dehumanizing about them? But if it wasn't for Haussmann's new Paris, there probably wouldn't have been so many cafés anyway. There certainly wouldn't have been those giant railroad stations, those restaurants and concert halls, or the new parks like the Bois de Boulogne that made Paris what it was.

When he declared himself emperor in 1852, the rebuilding of Paris was one of Napoleon III's highest priorities. Only the

Gustave Caillebotte, *Paris: A Rainy Day* (1876–7). Despite the weather, and the Impressionism, the critics raved about this depiction of the Place de l'Europe for its subject matter and technique.

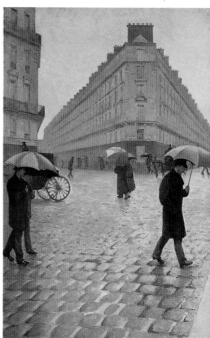

1889 Alexandre Gustave Eiffel's famous tower is completed, containing more that 7,000 tons of iron.

1893 There are riots in the Latin Quarter of Paris after a model who has performed a striptease for some art students is arrested by gendarmes and fined 100 francs.

1914 The first German air raid rains down on Paris on August 30.

best would do—he had his reputatiion to think of, after all—so he appointed *Georges Eugène, Baron HAUSSMANN* (1809–91) as Prefect for the Seine. Soon the remains of old medieval Paris were being swept away and the new boulevards, with their unusual triangles and wedge-shaped buildings, were emerging from the rubble—providing monumental views of the Arc de Triomphe and other Parisian sights. The Franco-Prussian War (*see page* 64) held up the rebuilding work and seriously damaged the park at the Bois de Boulogne. The Paris Commune that followed burned down the center of the

> ### NAMES IN THE FRAME
> *Was* **Gustave Caillebotte** *(1848–94) an Impressionist? His paintings of Parisian street life are much more finished than a Monet or a Renoir, but they depict real life, and they do have figures cut off by the frames, Japanese style (see page 34). See his* Paris, a Rainy Day *(1876–7), which dominated the Impressionist exhibition in 1877 with all those columns and umbrella handles dividing the picture, like a Degas.*
>
> *He left his enormous collection of Impressionist paintings to the nation when he died at the age of only 46, on condition they went to the great galleries at the Luxembourg and the Louvre. This was a controversial move, and the state didn't finally agree to have the whole lot until 1928—at which point his widow decided to repudiate the will.*

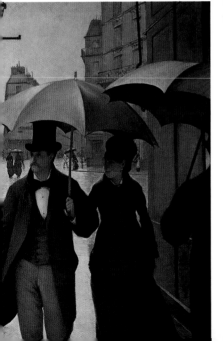

city, and it had to be rebuilt all over again. The emperor was deposed after the defeat by the Prussians, but his vision was continued during the Third Republic.

The railroads that speeded them out of town with their easels (*see page 26*), the theaters where they painted the dancers (*see page 58*), and the parks where they painted Parisians at play (*see page 54*), made Haussmann's Paris central to the lives of the Impressionists. And the Universal Exhibitions between 1855 and 1900 brought enormous exhibition halls and an appetite for art that fed into their work—though the Impressionists weren't allowed to exhibit in an official exhibition show until 1900. Impressionism would have looked different without Haussmann.

1854 Elisha G. Otis demonstrates his new safety elevator to the New York public by cutting through the ropes while he's inside it and plummeting earthward until the safety ratchets halt him.

1858 Queen Victoria and President Buchanan exchange the first transatlantic cable messages. Hers says "Glory to God in the highest, peace on earth, good will to men."

1865 Lewis Carroll, a reclusive Oxford don, is stunned when the story he has told at a children's picnic, *Alice Under the Ground*, becomes a hit bestseller when published with illustrations by political cartoonist John Tenniel and a slight title change.

1854~1870

Mountains Through Windows
Japanese prints

In one of the first examples of enforcing free trade with the threat of military force, the American naval commander Commodore Matthew PERRY (1794–1858) managed to push the Japanese shogun warlords into a trading treaty in 1854. It was the end of a period of 216 years when Japan was officially cut off from the rest of the world and it sparked the beginning of a new craze among Western artists.

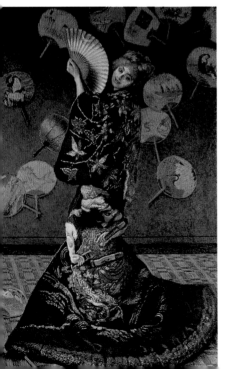

T he ink was hardly dry on the treaty before Japanese artifacts began finding their way to Europe. A shop called Le Porte Chinoise opened in Paris as early as 1862, selling fans and kimonos, and everything Japanese was suddenly immensely fashionable. Monet's wife Camille bought a kimono and he painted a full-length portrait of her wearing it while waving a fan alluringly: *La Japonaise* (1875–6). The public loved it, though Monet later described it as "trash."

But by the far the most influential were the Japanese works of art, especially the woodblock prints that flooded into France during the 1850s. They were called

TECHNIQUES

One of the extraordinary things about the woodcut prints was that the artists didn't really use perspective. They indicated depth by having figures overlapping each other—and pushed this to an extreme in their long thin vertical pictures known as *hashirakake*, designed to fit neatly along the pillars in Japanese houses. The Impressionists loved them. Check out, for example, the Degas painting *Mary Cassatt at the Louvre* (1885), where the figure is cut off in the middle by a pillar.

Claude Monet, *La Japonaise* (1875–6). The picture actually shows his wife Camille wearing one of the fashionable new Japanese kimonos and fluttering her fan, not the Japanese girl the title implies.

1868 The Meiji Restoration ends the Tokugawa shogunate that has held power in Japan since 1603. The city of Edo is renamed Tokyo (meaning eastern capital).

1869 Japan's Kirin Brewery is founded at Yokohama, under the name Spring Valley Brewery.

1870 The *Yokohama Mainichi Shimbun* begins publication in Japan; the following year it will become the country's first daily paper.

ukiyo-e, which meant "images of the floating world," and Impressionists started collecting them.

Artists like Degas (*see page 58*) and Van Gogh (*see page 114*) were particularly influenced by the bold blocks of color they used—especially the contemporary Japanese master Ando Hiroshige (*see* box). In fact, they were about to spawn a whole new era of poster art, led by Toulouse-Lautrec (*see page 118*). But most of all, they loved the way that, because they had been cut off from Western art for more than two centuries, the Japanese didn't use the conventional methods of organizing perspective, or showing depth or even arranging things neatly inside the frame. In other words, they didn't follow the techniques or traditions of practically any Western artist worth the name since the days of the Renaissance.

No, Hiroshige and his friends seemed to be anticipating snapshots by cutting off figures with the frame, or slicing them in half with a pillar. The Impressionists copied the idea for all it was worth, introducing diners sliced in half by pillars, or featuring half a prostitute getting up from a table. Check out Degas' *Women on a Café Terrace* (1877) or his long thin pictures of women with parasols. Like the Impressionists, the creators of the *ukiyo-e* were also obsessed with theaters, prostitutes and bathing.

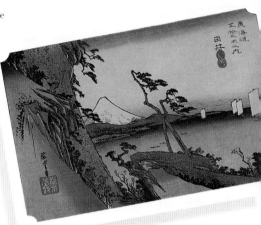

Ando Hiroshige, *The Peak of Satta near Yui* (1833): a whole new way of making art, as far as Europeans were concerned.

NAMES IN THE FRAME

Ando Hiroshige *(1797–1858) dominated Japanese art during the first half of the 19th century. A fire warden, and the son of a fire warden, he had a prodigious output, churning out over 5,400 prints by the end of his life. He died in Tokyo—then known as Edo—of cholera in the great epidemic that swept the world in 1858. Hiroshige was rivaled by his contemporary* **Katsushika Hokusai** *(1760–1849), also from Tokyo, whose* Thirty-Six Views of Mount Fuji *(c. 1826–33) may have been a major influence on Monet when he began painting the same views over and over again (see page 120).*

1855 Gustave Courbet's work is rejected by the Paris Exhibition so he sets up a show of his own in a nearby shed.

1865 The French silk industry calls Louis Pasteur in to treat a silkworm epidemic called *pébrine*. He eradicates it by isolating the infected eggs.

1872 The Jesse James gang robs its first passenger train in Iowa, but only gets away with $6000 instead of the $75,000 they had been told would be on board.

1855~1903

Something Like God
Pissarro

Poor old Pissarro always had a tough time of it. He never quite made it financially, he was beset with difficulties, and—like other Impressionists who had trouble with their eyesight—he died blind. But he knew everybody, he did everything he could to stop the bitter battles between his colleagues, he never blamed anybody—and he never stopped painting.

The trouble is, he was always a bit of an outsider. *Camille PISSARRO* (1831–1903) was older than the other Impressionists. He was born in the West Indies (his father married his own aunt) and ran away to Venezuela with a Danish painter. He arrived in Paris in 1855, just in time to see the World Fair and the independent exhibition of pictures by Courbet (*see page* 21) which had been rejected by the Salon. And he had a genius, not just for painting, but also for making friends. Soon he was pals with Courbet, Corot (*see page* 20), and Manet (*see page* 40)—and he met Monet (*see page* 46) in

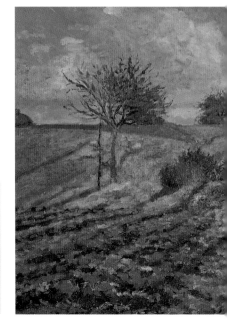

Camille Pissarro, *White Frost* (1873): a typical Pissarro landscape, in which he included a figure of a woman, something none of the Barbizon painters would ever have contemplated.

Going dotty

Pissarro may have been the most intellectual of the Impressionists, but critics have also accused him of being the dullest. In 1886, he came to the same conclusion himself, and started painting in tiny dots along the lines pioneered by Seurat (*see page* 92). Result: his Impressionist friends shunned him and his wife tried to drown herself. By 1890, he had given up dots and returned to painting outdoors, intuitively interpreting what he could see.

1888 English publisher Henry Vizetelly is imprisoned for three months on obscenity charges after publishing Zola's *La Terre.*

1894 Conan Doyle tries to kill off his famous detective in *The Memoirs of Sherlock Holmes,* but has to resurrect him after a public outcry.

1901 Scot Hubert Booth invents the first electric vacuum cleaner. It has an electric pump to suck dust down a tube and through a cloth filter.

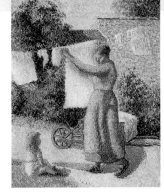

Camille Pissarro, *Women Hanging out the Washing* (1887): he was always fascinated by working women.

1859 just as the whole Impressionist idea was beginning to come together. "He is a man worth consulting," said Cézanne (*see page 50*). "and something like God himself."

It slowly dawned on Pissarro's family that he was going to be an artist after all, despite the fact that he could sell almost nothing and lived in grinding poverty. At the outbreak of war in 1870, he escaped to London—painting the Crystal Palace (*see page 30*)—and came back to find that his home had been used as a butcher's by the German invaders and his paintings employed as duckboards in the garden.

He was the only one of the Impressionists to exhibit in all eight of the famous exhibitions that launched the movement (*see page 68*), and in later life he described the technique as being about "reflecting color and light using unmixed colors"—easy to explain, but it took a lifetime to perfect. In the end, he never really felt he got there himself.

NAMES IN THE FRAME

Pissarro started by painting landscapes with the occasional figure in them. By 1880, it was the other way around, and he was churning out pictures of peasant women—described by Degas as "angels go to market." He painted them on canvas, on fans, and on crockery, sometimes in pastel and sometimes in gouache. His eldest son **Lucien** *(1866–1944) went back to landscapes, moved to England, and founded an influential printing press in London's Hammersmith.*

1857 The Indian Mutiny begins with a rumor that the new gun cartridges have been smeared with either pig fat, which would offend Muslims, or cow fat, which would offend Hindus.

1869 Philosopher John Stuart Mill campaigns for women's rights with the publication of The Subjection of Women.

1876 Grieg writes the music to accompany a stage production of Ibsen's Peer Gynt.

1855~1903

Music and Movement
Whistler

James A. McNeill Whistler, Arrangement in Grey and Black No. 1: The Artist's Mother (1871).

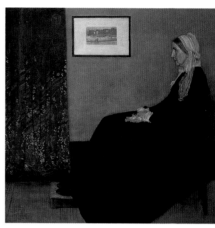

"I only know of two painters in the world," said an enthusiastic woman who'd just been introduced to Whistler. "Yourself and Velázquez." "Why drag in Velázquez?" answered Whistler gently. It was an exchange that was typical of the man— uncategorizable, witty, completely full of himself, at a time when he was battling away in London and Paris for many of the ideas the Impressionists held dear.

James Abbott McNeill WHISTLER (1834–1903) was actually born in Lowell, Massachusetts, where he failed at West Point Military Academy, then failed as a naval cartographer, before dashing off to Paris—as so many young people did in

Splendid isolation
Impressionism was one of the first movements in art that was explicitly unpopular. The public didn't remotely understand what the Impressionists were trying to do, and in the end the artists were rather proud of that. Like the other members of the Aesthetic Movement, Whistler felt this was rather a good thing—it made them feel sensitive and alone in a sea of idiots. "There never was an artistic period," said Whistler enigmatically. "There never was an art-loving nation."

those days—to join the bohemians. There he met Degas and Courbet (*see page 21*) and flung himself into the city's café society and all the heated, earnest debates of the young Impressionists.

Four years later, Whistler moved to London, after his picture *Au Piano* (1859) had been rejected by the Salon; it ended up alongside Manet's work at the Salon des Refusés (*see page 52*). Meanwhile, he popped backward and forward across the Channel, keeping up with the latest trends and cultivating his image as one of the first dandies—the fashion later pioneered by *Oscar WILDE* (1854–1900) and *Aubrey BEARDSLEY* (1872–1898) in the 1880s and 1890s—with a world-weary, urban chic.

1886 Ferdinand Schumacher's oatmeal mill in Akron, Ohio, catches fire and 100,000 bushels of oatmeal are destroyed. What's more, he wasn't insured.

1895 Booker T. Washington makes a speech agreeing that America's Blacks will withdraw from politics in return for a guaranteed education.

1901 King C. Gillette sets up a company making safety razors above a fish store in Boston.

NAMES IN THE FRAME

One of Whistler's Parisian contacts, who influenced him a great deal, was the Romantic French painter **Henri Fantin-Latour** *(1836–1904), who specialized in group portraits and still-lifes. He joined the Salon des Refusés (see page 52) along with the other Impressionists, and then fell in love with the music of* **Richard Wagner** *(1813–83) and ended up somewhere completely different. See his* Hommage à Manet *(1870).*

Now the former is in the Louvre in Paris and the latter is in the Tate in London, but at the time the whole suggestion of mixing up the senses in that way enraged the critics—including the great art writer John Ruskin—and the difficult business ended up in court (*see page 84*).

Like Wilde, Whistler had nothing to declare but his genius. That made him a pioneer of the Aesthetic Movement: sharp-witted, urbane, and full of contempt for the countryside, in tune with the French writers (*see page 70*) who were doing so much for the Impressionist cause.

Whistler was fighting the same battles as the Impressionists—and in London he was doing so almost on his own. Like them, he was fascinated by the arrangements in Japanese prints. He wasn't as interested in light as they were, but he was fascinated by color, impressions, and the senses. To make the point more strongly, he indulged in what his contemporaries thought were totally bizarre titles. The famous portrait of his mother he called *Arrangement in Grey and Black* (1871): the gray and the black referred to her hair and her dress. Then there was his painting of Old Battersea Bridge with fireworks in the background, which he called *Nocturne in Blue and Gold* (1865).

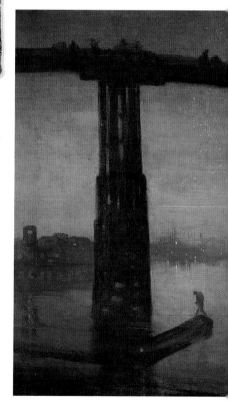

James A. McNeill Whistler, *Nocturne in Blue and Gold* (1865): or fireworks, in other words. He painted a series showing London by night in the 1860s.

1856 Gail Borden introduces condensed milk, but New Yorkers don't appreciate it; they're used to watered milk colored white with chalk and thickened with molasses.

1861 Britain almost enters the American Civil War on the side of the southern states, after Federal officers snatch southern representatives off a British ship, the *Trent*.

1863 Vivekananda is born in Calcutta. He will become a key figure in the 19th-century revival of Hinduism, visiting Chicago's World Parliament of Religions in 1893.

1856~1883

Black Rebellion
Manet

The frock-coats-and -boots brigade.

What we desperately need, said the poet Baudelaire (see page 70), is a painter of the modern world who can demonstrate "how great and poetic we are in our frock-coats and patent leather boots." His great friend Manet took him at his word and showed him the way, painting the world as it really was. Manet's first exhibition at the Galerie Martinet in 1863 included fourteen of his best works—including Music in the Tuileries (1862)—and it took the Impressionist world by storm.

Best friends

Manet's great friend and contemporary was Degas (*see page 58*). Both were dandies. Both craved respectability in a way the others didn't. Degas had studied at the École des Beaux-Arts—the most respectable Parisian art school of all—where Renoir and Pissarro also went to classes. They disagreed on politics and on one occasion, Manet sliced Degas' painting of his wife in half because he thought it was unflattering. But they had enormous respect for each other's work. Influenced by Manet, Degas left Classical art behind and began painting what he saw.

I t was a storm, too. The critics hated his rebellion against artistic convention. They hated the way he concentrated his coloring on black, with sudden shifts between light and dark, and hardly any shading at all. They particularly hated his spontaneous bold brushstrokes. Only his friend Zola (*see page 70*) defended him. The tragedy was that, although *Èdouard Manet* (1832–83) was the Impressionists' main inspiration—a kind of older brother —all he really wanted was acceptance by the establishment. He always claimed he had "no intention of overthrowing old methods of painting, or creating new ones."

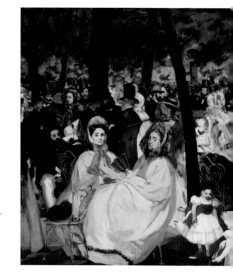

Edouard Manet, *Music in the Tuileries* (1862): he attended all the best parties and painted the modern world as he knew it, to no avail.

1866 Herman Melville takes a job as a customs inspector in New York and gives up writing novels after his masterpiece, *Moby Dick*, fails to make him any money.

1872 Calvert Vaux builds a massive Islamic-style building known as Olana on the Hudson River for painter Frederic E. Church.

1883 C.D. Harrod employs 100 staff at his London store. If they are late for work, they are fined a penny-halfpenny for every fifteen minutes.

Painters and writers have to be concise, said Manet. "The verbose painter bores: who will get rid of all these trimmings?" And then, answering the question himself, he tried to do what he could.

It's all very well being a great rebel if you don't care what the establishment thinks of you, but if the one thing you want in the whole world is to have your paintings accepted by the Salon, then you have a hard life—and the Salon turned Manet down over and over again. The poor man was a complicated mixture. He was a typical dandy, an upper-middle-class *flâneur*. He knew all the fashionable people and went to all the best parties. "Why slop about in slippers?" he told his bohemian Impressionist friends, and refused to take

Edouard Manet, *Morisot* (1884): during their period of mutual support.

part in their exhibitions. Yet he was also a left-wing republican, painting barricade scenes during the Commune of 1871 (*see page* 64).

By 1867, he had lost his nerve completely, and for the next five years he was nursed back to confidence by the young Impressionist Berthe Morisot (*see page* 60)—who later married his brother Eugène. Under her influence, he gave up black and painted the most Impressionist paintings of his career. Then, just as the Salon was finally noticing him, he fell ill, developed gangrene, had his leg amputated, and died. It was a tragic end for one of art's most brilliant revolutionaries.

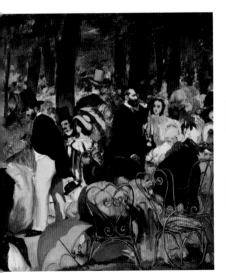

NAMES IN THE FRAME

Another of Manet's friends was the French artist **James Tissot** *(1836–1902), who had gone to England during the Franco-Prussian war and stayed there—putting into practice some of the same ideas as Manet by painting real life as he saw it. Tissot was Manet's companion on a visit to Venice at the end of 1874. Check out the very Impressionist result of Manet's sojourn,* The Grand Canal *(1874).*

1860 The first modern Eisteddfod festival is held in Wales and poets and musicians flock from all over the country to take part.

1861 In Britain, the first daily weather forecasts are issued. They won't be available in the US until 1869.

1862 A.T. Stewart brings several innovations to his New York department stores: price tags on each item, female shop staff and 10 percent discounts for the wives of clergy and teachers.

1860~1864
Student Revolt
The Atelier Gleyre

Poor old Charles GLEYRE (1808–74). He was a fantastic Romantic painter in the traditional mold, and he was kind and generous—so generous, in fact, that his art school almost went bankrupt and was forced to close. But he is mainly remembered by posterity for a series of remarks which his pupils believed were remarkably stupid. That's the problem when your pupils suddenly turn out to be part of the greatest art movement of the 19th century.

B y strange coincidence, many future Impressionists were studying at the Atelier Gleyre in 1862, and most of them for very different reasons. Pissarro had already met Monet and Cézanne at the Académie Suisse in Paris, where a former model allowed penniless art students to come and practice their drawing. But his respectable parents persuaded him to go somewhere more classy, which took him to Gleyre's in 1862.

Renoir had enrolled there two years before Pissarro. He was joined by Frédéric Bazille (*see page* 49), desperately trying to distract himself from his medical studies, and Alfred Sisley, the Englishman who had turned his back on his family's business in England to

Flatmates
Renoir and Monet had been flat-sharing in an apartment lent to them by a rich artist, then Renoir moved in with Bazille when he rented a studio in the Batignolles district—in the same building where Sisley was living. The Batignolles was going to prove important in their future development (*see page* 56). Meanwhile, Monet fell behind on the rent and good old Manet stepped in to rescue him from eviction.

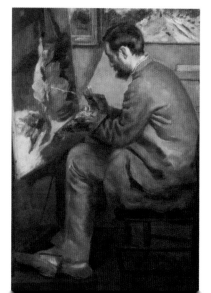

Pierre-Auguste Renoir, *The Painter Frédéric Bazille* (1867). The two men were together at the Atelier Gleyre with Sisley, Pissarro, and Whistler.

1862 Adah Isaacs Menken appears at New York's Bowery Theater in *Mazeppa*, an adaptation of Byron's 1819 poem, and causes a sensation by riding half-naked on horseback across the stage.

1863 La Villette slaughterhouse opens in Paris, designed by Baron Haussmann.

1864 Gerard Adrian Heineken develops a special kind of yeast with which to make the beer that reaches the parts other beers can't reach.

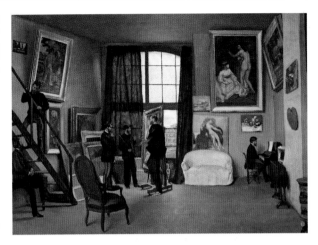

Frédéric Bazille, *The Artist's Studio* (1870): portraying Manet, Monet, Zola, Renoir, and Bazille himself.

study art in Paris. Then along came Whistler, on his way from the US to London (*see page* 38). It was a formidable combination of talents.

Life with Gleyre was a relaxed business. It meant painting a series of models, and also seems to have involved acting in obscene plays and charades with extraordinary scenery painted by some of the greatest artists in history—not that they knew it at the time. Gleyre left them to get on with it: apart from encouraging their originality and their passion for painting out of doors, he just popped in once a week to inspect their paintings.

But he didn't really understand the ideas they were fumbling their way toward. "Can't you understand that the big toe of Germanicus has to be more majestic than the toe of the local coal-man?" Gleyre exclaimed to Renoir. But Renoir never did—and neither did his fellow students. When Gleyre proclaimed "In drawing a figure, one should always think of the antique," an enraged Monet led his friends out of the studio in protest.

Gleyre gave up in 1864, partly because of financial problems and partly because his eyesight was failing, and the young Impressionists were left to scrape together an income as best they could.

NAMES IN THE FRAME

*In a way it was **Louis XIV** (1638–1715) who made Impressionism possible. The Sun King had introduced a number of measures to encourage art in the country, as a result of which there were more art schools in Paris by the 1870s than there were in any other city in the world. Foreigners flocked there to study. The centerpiece of all this was the École des Beaux-Arts, founded in 1648. When Renoir took his entrance exam there in 1862, he came 68th out of 80 students.*

1862 English explorer John Speke confirms that Lake Victoria is the source of the Nile River.

1868 British novelist Wilkie Collins writes *The Moonstone* and explains the secret of his success: "Make 'em laugh, make 'em cry, make 'em wait."

1874 J.T. Barnum's "Greatest Show on Earth" plays to 20,000 people a day, paying 50 cents each.

1862~1899

The Forgotten Impressionist
Sisley

Just painting in the rain.

Whether Sisley was truly fascinated by the Saint-Martin Canal in Paris, or whether he judged that pictures of it would sell well, nobody will ever know. Either way, he painted it almost to destruction. Come rain, come shine, come misty mornings, there he was—painting the Saint-Martin Canal to within an inch of its life. And, failing that, it was the Seine at Marly. It was curiously committed behavior for an Impressionist.

Alfred SISLEY (1839–99) was actually English. He was sent to France when he was 18 to learn the language and launch his career in commerce, and he never returned home. Instead he joined the École des Beaux-Arts in 1862 and met the rest of the Impressionist gang, and, though he

NAMES IN THE FRAME

In these days of the Channel Tunnel, it's easy to imagine that the English and French never visited each other's capitals over a century ago, but Sisley did. France and Britain still regarded each other as their main potential enemies, yet the aristocracy and intelligentsia traveled freely between London and Paris. Whistler (see page 38) was at home in both. As the Impressionists were becoming famous, Paris became the center of artistic life and a whole new influx of young visitors flocked to see it for themselves.

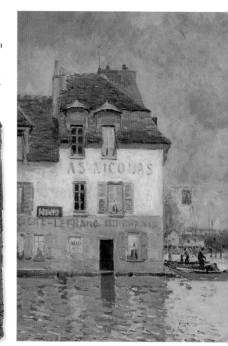

lived in England again briefly during the Franco-Prussian War, that was that.

All the Impressionists were different, but Sisley was different in a new way. He never stopped being an Impressionist. He always stuck to the original principles and techniques, and he stuck to the original idea of painting landscapes. He never wandered off painting prostitutes, peasants, or party-goers like the rest of them. He didn't necessarily choose the most beautiful scenes—he preferred painting factories, suburbs, or piles of sand: see his *Seine at Port-Marly: Piles of Sand* (1875). But it wasn't the sideways look at urban life that the others stuck to. The great art critic Kenneth Clark argued that in terms of "impression," no paintings were as pure as Sisley's pictures of Hampton Court during the war (1870–1).

The second reason Sisley was different was that he was quieter. He didn't storm around in the cafés like the others. He was always shy and unassuming, and never really found the success that the others enjoyed. He stayed poor until his death. But, unlike the rest, he never felt dissatisfied by Impressionism.

The third reason is that Sisley was particularly fascinated by the sky. He didn't dissolve his paintings completely into light and color, as Monet was doing by the end, but Sisley's mix of light and color are some of the most important elements of his paintings. His rivers may look still, but his skies race on ahead.

Flood waters run deep

When the Seine burst its banks in 1872, it was an important moment for Sisley. He raced down and painted the first of his series of flood paintings at Marly, a village between St-Germain-en-Laye and Versailles, west of Paris. He lived in Marly himself from 1876 to 1879, when he moved to Sèvres. The most famous flood painting—*Flood at Port-Marly* (1876), showing a flooded wine merchant's—changed hands at 43,000 francs in 1900, and was given to the Louvre eight years later. It was a bit late for Sisley. He died of cancer of the throat in January 1899.

Alfred Sisley, *Flood at Port-Marly* (1876). He liked his own skies, saying, "Not only does it give the picture depth . . . it also gives movement."

1862 In England, Crosse and Blackwell introduce the first canned soups.

1870 Prussian troops besiege Paris and the hungry population eat cats, dogs, and even the elephants Castor and Pollux from the zoo.

1885 British journalist W.T. Stead buys a girl of 13 for $7, to prove the existence of a white slave trade dealing in children between London, Paris, and Brussels.

1862~1906

Red Trees and Brushstrokes
Cézanne

Getting the color just right.

For someone hailed as the "father of modern art" and the greatest artist of his time, it's strange that Cézanne was near despair so much of his life. But then he had a lot to think about. He wanted to master Impressionism but he also wanted to transcend it. He wanted bright colors and solid landscapes, but he couldn't stand mess and disorder. And he wanted to turn Impressionism into "something more solid and enduring, like the art of museums."

Paul CÉZANNE (1839–1906) was older than Renoir but he joined the other Impressionists at the Académie Suisse, and argued with them in the cafés along with everyone else. It was during a trip with his mentor Pissarro that he learned to use just the three primary colors and their variants. But strictly he was more of a Post-Impressionist than an Impressionist.

He wasn't very interested in the rules of composition or perspective; check out, for example, his *Still Life* (c. 1878) in the Lecomte Collection. In fact, he probably wouldn't have made it as an artist in any other age, because he wasn't much good at copying or drafting. And while the Impressionists tried to dash their impressions off onto the canvas,

Paul Cézanne, *L'Estaque* (1878–9): his view of the Gulf of Marseilles, near where he lived from 1870.

1890 In *News from Nowhere*, William Morris describes waking a century later to find that London has been transformed into a pastoral, Arts and Crafts style city. Nightmare!

1894 Marshal John Selman shoots Texas gunslinger John Wesley Hardin in the back of the head as he's playing poker in the Acme Saloon. He claims Hardin had insulted him.

1903 The first "garden city", Letchworth, is built according to the ideas of Ebenezer Howard that residents of inner cities should be moved out to green towns surrounded by a belt of farmland.

Cubic

Was Cézanne the first Cubist? Certainly the early Cubists like Pablo Picasso (1881–1973) were building on his lead, trying to investigate the relationship between form and color—sometimes ignoring the visual shape of a subject to paint its structure as a whole. Cézanne had bent perspective to make things look deeper. And he taught that artists should look for the cone, the sphere and the cylinder in nature, which sounds fairly Cubic to me.

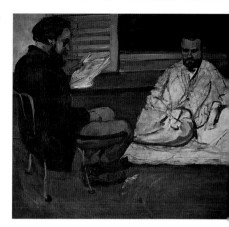

Paul Cézanne, *Paul Alexis reading a manuscript to Emile Zola* (1869–70): painted before they argued.

Cézanne worked and worked away at every piece. Having your portrait painted by Cézanne could turn into a lifetime's occupation. One portrait of the art dealer *Ambroise VOLLARD* (1868–1939) was abandoned after more than a hundred lengthy sittings.

Cézanne suffered from a form of self-disgust and was always rather isolated. He returned to his house in Aix in a rage after the public reception to the first Impressionist exhibition in 1874. "When one is born down there, nothing else seems to matter," he wrote. He was doing it all by himself and claimed that nothing the critics in Paris said seemed relevant.

Cézanne was much more interested in structure and balance in his pictures than the shapeless Impressionists. He wanted his paintings to look permanent. He shared the Impressionist passion for getting out of doors and he also painted still-lifes and apples over and over again in an act of rebellion against the Salon, which tended to believe that still-lifes lacked moral

seriousness. In 1886 he inherited his domineering father's fortune and could afford to live an isolated life in the south of France, struggling over the great issues of contemporary art. He struggled and seems to have won.

NAMES IN THE FRAME

Cézanne became friends with Zola (see page 70) while he was at College Bourbon, and the friendship was very important to him. He bombarded Zola with letters and poems, most of them obsessed with sex and death; in one he describes a dream in which he kissed a beautiful woman who immediately turned into a skeleton. But when Zola published his novel L'Oeuvre *in 1886—featuring an embittered artist, who is clearly based on a mixture of Cézanne and Manet—it was over between them.*

1862 General Daniel Butterfield composes the bugle call known as "Taps" to be played at lights-out and at military funerals.

1869 Francis Galton's book *Hereditary Genius* proposes arranged marriages between wealthy women and distinguished men.

1870 Insurance market Lloyd's of London is incorporated, 182 years after its founding. Its office contains the huge Lutine Bell salvaged in 1859 from the frigate *HMS Lutine*. It is rung once for bad news and twice for good.

1862~1919
The Pleasures of the Flesh
Renoir

Renoir researches his favorite subject.

You only have to see the mass of flesh in Renoir's paintings of women, and the sheer joie de vivre in many of the others, to understand his main motivation: it was the pursuit of pleasure. "One doesn't paint for amusement," said Gleyre (see page 42) scoldingly, to which Renoir replied: "But if it didn't amuse me, I shouldn't paint."

That's the first thing that makes *Pierre-Auguste* RENOIR (1841–1919) different from the other Impressionists: he lived for fun, pleasure and sensuality. The second thing also explains why there is quite so much naked flesh in Renoir paintings: he loved the history of painting, traditionally a fleshy business, and believed it was really important to learn from the traditions of art. While Pissarro was calling for the Louvre to be burned down, Renoir was

Lise
Renoir's most famous model was Lise Tréhot (1848–1924), the sister of the mistress of his friend the architect Jules Le Coeur (1832–82). The sisters' father was an out-of-work postmaster from the small country town of Ecquevilly. Lise quickly became Renoir's mistress and his favorite model, appearing in paintings like *Lise with Parasol* (1867). She married an architect in 1872 and destroyed her letters from Renoir but kept the paintings until she died.

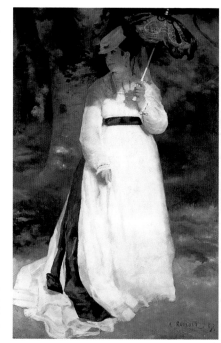

Pierre-Auguste Renoir, *Lise with Parasol* (1867): a view of his most famous model in a blur of powdery, feminine shades.

1886 The element germanium is discovered by a German physicist. Dmitri Mendeleev hadn't known about it when he published the periodic table of elements in 1870, but he'd suspected its existence.

1904 *Peter Pan* is performed for the first time in London and audiences are asked to clap to save the life of Tinkerbell.

1919 The pogo stick is patented by George B. Hansburg and will feature in a dance scene in the *Ziegfeld Follies*.

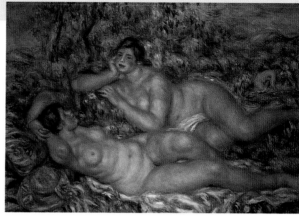

Pierre-Auguste Renoir, *The Bathers* (1918–19): he really seems to have got off on the feistier side of painting. Now in the Musée d'Orsay, Paris.

spending every moment wandering around it, gazing up at the Watteaus and Veroneses —and trying to drag the reluctant Monet along there with him.

The third thing was that he wasn't much interested in theory, and couldn't stand the long theoretical arguments in the cafés lasting well into the night: they made it hard for him to get up the next morning and paint. Renoir was the son of an impoverished tailor and he started painting porcelain in a factory at the age of thirteen. When the factory went bankrupt, he turned to painting fans to earn a living. He was always practical, managing the early sales of Impressionist paintings, desperately eking out enough money to buy paints using hand-outs from wealthier people like Bazille (*see* box). He once stole bread from his own mother's table so that Monet could eat.

But despite these differences, it was Monet and Renoir together—more than anyone else—who came up with the technique that made their name, on a summer working out of doors by the Seine in 1868 (*see page* 62). Influenced by Monet, Renoir's pictures became lighter and less finished. He would spend Sunday afternoons and evenings in the cafés and theaters, portraying those vivid thrilling splurges of color and life.

Renoir's nudes were criticized in the newspaper *Le Figaro* as "a mass of decomposing flesh, with green and purple patches like a corpse in a state of utter putrefaction"—but time was on his side.

NAMES IN THE FRAME

It was through Renoir that **Frédéric Bazille** *(1841–70) met most of the other Impressionists and became a key member of the group. He was the son of a rich wine merchant near Montpellier, and came to Paris as a medical student before he joined the Atelier Gleyre (see page 42). He was calm and generous, continually bailing out the others. He told his parents he was planning an independent exhibition together with Courbet and Corot (see page 20), but he was killed by a Prussian sniper at the age of 29.*

1862 It becomes illegal to distill your own alcohol without a licence in the US, but "moonshiners" continue regardless.

1865 John Henry Newman writes the poem *The Dream of Gerontius;* Edward Elgar will be inspired by it to write one of his most famous works, of the same name.

1867 The Dominion of Canada is set up, comprising Quebec, Ontario, New Brunswick, and Nova Scotia. However differences between French and English settlers do not go away.

1862~1926
On the Spot
Monet

Discovering painting
by the seaside.

There's nothing quite like being influenced by your parents' pecuniary circumstances. It was the financial difficulties of Monet's shopkeeper father that forced them to move to the coast at Le Havre when Monet was five—and there he met Boudin (see page 27). Boudin persuaded him to be a landscape painter and the rest, as they say, is history.

Claude MONET (1840–1926) was born on exactly the same day as Rodin (November 14, 1840). He was the central figure of Impressionism: it was his passion for painting out of doors that persuaded the others to try it, and he stuck with the technique for longer than anyone else. It was Monet who dragged them all off to paint in the forest of Fontainebleau after

NAMES IN THE FRAME

Monet was hard to please. He didn't like Boudin's work at first and it was his descriptions of Gleyre in his writings that left the latter with a reputation as a bit of a fool (see page 42). Monet and Pissarro went to London during the Franco-Prussian War and visited the National Gallery and the Victoria & Victoria & Albert Museum to look at the Constables and Turners—but Monet didn't think much of them either. You have to forgive that in a genius.

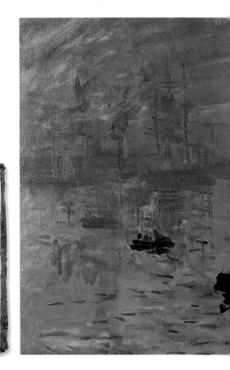

1898 The First German Navy Law is passed, laying out plans for the construction of a large navy. The British government is alarmed because the only reason for this must be to attack Britain.

1912 Harry J. Williams writes the song "It's a Long Way to Tipperary" with the words "Goodbye Piccadilly/ Farewell Leicester Square."

1926 Customs officers try to charge 40 percent tax when Brancusi's *Bird in Space* is imported to the US, because they say it is "a manufacture in metal."

Gleyre's school closed down in 1864. What's more, it was the title Monet gave one of his pictures—*Impression: Sunrise*—that inspired the originally ironic name given to the whole movement.

Not a bad haul for someone who lived in such appalling poverty from 1876 to 1880 that he was constantly being bailed out by Manet, Zola and others so that he could continue to live in Argenteuil. At one stage Monet even considered killing himself. In 1883 he moved to Giverny, where he created an extraordinary garden—including the famous waterlilies (*see page* 128). After that, it all began to come right, and even better than right following his joint exhibition with Rodin in 1889 (*see page* 102). By the 1890s, he had become the most famous Impressionist of them all.

It was at that stage that Monet began painting the same scene over and over again (*see page* 120). The idea wouldn't have interested Classical artists, who believed there was one optimum way of painting, but to Monet it was a wonderful method of observing how the light changed. He used to paint all day long in the snow or rain, often accompanied by the writer *Guy de MAUPASSANT* (1850–93), who described him as being "like a trapper." Monet was completely committed to painting what he saw. He was "only an eye," as Cézanne said about him. "But my God, what an eye!"

The garden

Monet just loved his garden. Although they were a pretty urban bunch, always hanging around in cafés or brothels, the Impressionists came to have a soft spot for gardening. Monet led the way, moving to Argenteuil and then Giverny, and you can see what gardening was like for the Impressionists by looking at the paintings—people stroll around, wave parasols, and paint. There's not much work with trowels and rakes. The exception was Pissarro, whose garden paintings are full of women planting peas. Monet's house and garden at Giverny are still open to the public, and his gigantic paintings of them were donated to the nation after his death (*see page* 128).

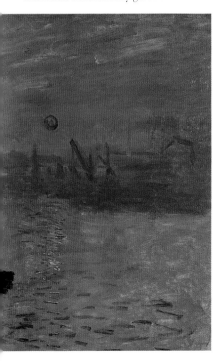

Claude Monet, *Impression: Sunrise* (1872): the picture that was destined to give rise to the name of a whole movement. It shows the harbor at Le Havre, facing south east.

1863 Sir Lawrence Alma-Tadema visits Pompeii and is inspired to begin painting archeological subjects.

1863 A specially designed jail for the Criminally Insane, Broadmoor Asylum, is established in Berkshire, England.

1863 Cattle rustling becomes widespread in Texas after one of the worst winters on record.

1863

Refuseniks
At the Salon des Refusés

Imagine that a small group of elderly conservatives was responsible for deciding what was "good" art and what was "bad." That was exactly the situation in Paris in the middle of the 19th century. If you could persuade the Salon that your art was acceptable and so get your work into the annual exhibition, then you would make it as an artist with the official imprimatur of approval. If you couldn't, you probably wouldn't. And the Salon jury guarded the entrance jealously.

The trouble was that, although the Salon had been open to all artists since the French Revolution, the Salon jury had extraordinarily conventional tastes. They liked beautifully finished paintings, preferably with historic or mythological subjects. They certainly didn't like the new works emerging from the avant-garde—these apparently half-finished pictures of modern landscapes and modern life. The jury included artists, but only ones who had already won the Salon medal, so it was a self-perpetuating system.

The White Girl

Whistler's *The White Girl* (1862)—he had given it the deliberately provocative and Impressionistic title *Symphony in White No 1*—had already been rejected by the Royal Academy in London. It showed his mistress Joanne Hifferman in a long white dress, with unkempt hair and a doe-eyed expression, standing on what had clearly once been a bear. The avant-garde critics pounced on the painting with excitement; it was natural, real, and modern and couldn't be further from old-style Classical painting.

Henri Gervex, *A Meeting of the Salon Jury* (1885): the old fuddy-duddies are shown voting to decide what passes for art and what doesn't stand a chance. Impressionist Art was usually out!

Matters came to a head in April 1863, when a particularly severe jury announced their decisions on the 5,000 works of art submitted. Renoir and Whistler (*see page 38*) got pictures accepted, but Manet (*see page 40*)—who had submitted three paintings—was rejected. The most conservative member of the artistic establishment had already warned Renoir that the shade of red he chose was too bright, so he wasn't feeling very well-disposed toward them.

There was a public outcry about the jury decisions, and just twelve days later the Emperor (*see page 32*) responded with a decree explaining that the artists'

> ### NAMES IN THE FRAME
>
> **Felix Bracquemond** *(1833–1914) was one of the exhibitors at the Salon des Refusés, a friend of Manet's, and the future art director of the Sèvres porcelain factory. He would be best remembered as an engraver, while his wife* **Marie** *(1841–1916), the reclusive painter, took up Impressionist techniques—much to the jealousy of her husband. See her painting* **Young Woman in White** *(1880).*

complaints were justified and that the rejected paintings should be exhibited in another part of the same building, the Palais de l'Industrie in the Champs-Élysées.

Of the 3,000 or so paintings that were shown in the so-called Salon des Refusés, two stood out for the critics. One was Whistler's *The White Girl* (*see box*) and the other was Manet's *Déjeuner sur l'Herbe*—which caused a sensation (*see page 55*) and established him as the leading avant-garde artist of the day. The sad thing for Manet is that he didn't want to be a dissident. He wanted nothing better than to gain the recognition of the Salon, but when it came, it came too late for him.

The Salon des Refusés also included paintings by Pissarro, Cézanne, and Bracquemond (*see box*). Other Impressionists were too early in their careers to have made it, but they recognized the power of an independent exhibition. When they faced the hostility of the establishment a decade later, it pointed the way forward for them.

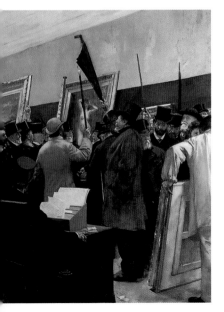

1863 The *Winged Victory of Samothrace* is found during excavations in Greece.

1863 American showpeople General Tom Thumb, 101cm tall, marries Mercy Bun, 81cm tall.

1863 Charles Kingsley writes *The Water Babies*, about the escape of working children to a life of bliss under the sea.

1863
Strange Lunch
Le Déjeuner sur l'Herbe

It was a bit of a bombshell for the French artistic establishment. There they were urging young artists to paint historic and Classical scenes, when suddenly they were confronted with a talented young artist called Manet producing what they saw as a half-finished painting of a picnic.

But what a picnic! A completely naked woman is gazing out of the picture, while two clothed men, not really looking at anybody in particular, loll around on the grass. According to the conservatives, it was just pornographic. Worse, floating in the background like a ghost is another semiclad woman clearly washing herself. The painting was originally known as *Le Bain* (*The Bath*).

Actually it was more rooted in artistic tradition than almost any other Impressionist work, inspired by two paintings by Renaissance artists: Titian's *Le Concert Champêtre*, which Manet owned a copy of, and the great Mannerist artist Giorgione's *Tempesta* (*see* box), the result of a youthful attempt to break the grip of Renaissance style 350 years before.

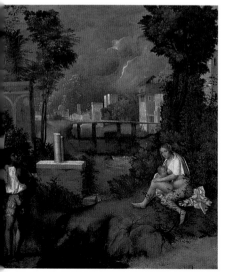

Giorgione's *Tempesta* (*c.* 1505): an inscrutable but much admired forerunner of Manet's famous picnic.

Tempesta
Giorgio da Castelfranco, known as Giorgione (c. 1476/8–1510), was a pupil of Bellini's, a follower of Leonardo's, and the first Venetian to experiment with small oil paintings. He died of the plague after only a few years of activity and only five peculiar and unintelligible paintings still in existence are definitely by him. Nobody now or at the time could understand what he meant in his most famous painting *Tempesta* (c. 1505). As in Manet's *Déjeuner*, there was a naked woman breastfeeding, but also an apparently unconnected shepherd, a flash of lightning over the city in the background, and an atmosphere of twilight before a storm.

1863 At a meeting in Geneva, the fundamental principles are agreed for an international Red Cross movement that will help wounded soldiers and victims of war.

1863 Georges Bizet's opera *The Pearl Fishers* premieres at the Théâtre-Lyriques in Paris.

1863 In England, the new Football Association draws up the definitive set of rules for the game of soccer.

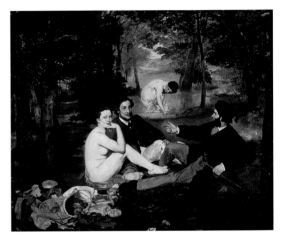

Edouard Manet, *Le Déjeuner sur l'Herbe* (1863): first shown at the Salon des Refusés in 1863 to a hostile critical reaction.

The man looking out was one of Manet's brothers. The other was his soon-to-be brother-in-law, the sculptor Ferdinand Leenhoff. The naked woman was Victorine Meurent (*see* box), who was also immortalized in the equally scandalous nude Manet painted two years later in *Olympia*. The Emperor declared that her presence made *Déjeuner* immodest, but the audience of the Salon des Refusés were completely knocked out by it.

The critics hated it. They hated the forcible brushstrokes, and the bright nude against the dark background. Above all, they thought it was dishonest: they didn't understand what it was trying to say and that irritated them. "I see garments without feeling the anatomized structure that supports them and explains their movements," wrote critic *Jules* CASTAGNARY (1830–88). "I see boneless fingers and heads without skulls. I see side-whiskers made of two strips of black cloth that could have been glued to the cheeks. What else do I see? The artist's lack of conviction and sincerity." But that was Manet's technique: he wanted to paint what we actually see, not the bone structure underneath.

The young Impressionists were awed by Manet's work. They started practicing large compositions with figures, painted out of doors. Impressionism had begun.

NAMES IN THE FRAME

Victorine Meurent *(1844–c.1885) was one of the tragic figures of Impressionism. She was the naked model in* Déjeuner sur l'Herbe *(1863), and* Olympia *(1865) and then ten years later she appeared fully clothed in Manet's* The Railroad *(1872–3). She had talents in her own right, as a guitarist and as an artist, and she managed to get a self-portrait accepted by the Salon in 1876. But she was fast becoming an alcoholic and died, unfulfilled, in desperate poverty just after her fortieth birthday.*

1864 Matthew Brady travels through the southern states with a wagonload of photographic equipment documenting the suffering wrought by the Civil War.

1867 Nelson's Column, with its statue and four lions, is unveiled in London's Trafalgar Square.

1870 French lawyer Leon Gambetta escapes from the besieged city of Paris by balloon.

1864~1877

Coffee and Absinthe

Batignolles and the Café Guerbois

Edgar Degas, *Singer With Glove* (1878): a café concert at full throttle.

Degas was fascinated by the way light illuminated the singers' faces.

Café concerts

For an artistic group who—with a few exceptions—showed such a fascination for the countryside and landscapes, the Impressionists were a pretty urban bunch. They were never more at home than they were in a café and they particularly enjoyed the new phenomenon, the café concert. Degas used to hang around with the singers at the café concert at the Ambassadeurs.

Whenever they want to start a new intellectual movement, people dash to a table in a café. Why? Partly because of the Impressionists. Movements had emerged from coffeehouses before, but the time when the Impressionist painters were young coincided with the great age of Parisian cafés. In fact there were at least 24,000 cafés in Paris alone, spilling out onto the new broad pavements, with a mixture of bowler-hatted types and prostitutes wandering by.

It was Manet's fault. He moved into an apartment at 34 boulevard des Batignolles, in the suburb squeezed between Montmartre and Les Ternes, and found himself the neighbor of Bazille (*see page 49*), Baudelaire (*see page 70*), Fantin-Latour (*see page 39*), Pissarro (*see page 36*), and Renoir (*see page 48*). He liked to spend his evenings loudly addressing his friends around a café table.

By 1866, they favored the Café Guerbois at 11 rue des Batignolles—especially on Thursdays. Soon they were joined by Cézanne (*see page 46*), Zola (*see page 70*),

1872 Blackjack liquorice-flavored chewing gum is introduced in New York; it is the first chewing gum to use chicle and to be sold in stick form.

1875 The Fijian king visits New South Wales and brings measles back to the islands with him, killing 40,000 Fijians out of a total population of 150,000.

1877 Richard Wagner comes to London to conduct some concerts at the Royal Albert Hall. While there, he meets Robert Browning, George Eliot, Queen Victoria and the Prince of Wales.

Sharpened wits

This is how Monet described the evenings at the Café Guerbois: "Nothing could have been more stimulating than the regular discussions which we used to have there, with their constant clashes of opinion. They kept our wits sharpened, and supplied us with a stock of enthusiasm which lasted us for weeks, and kept us going until the final realization of an idea was accomplished. From them we emerged with a stronger determination and with our thoughts clearer and more strongly defined." And that was just when they were arguing over who should pay the bill.

and a range of other artists and critics. It was high-octane conversation, angry, intellectual and sometimes violent, because Manet didn't like being contradicted. On one occasion he challenged the critic *Edmond Duranty* (1833–80) to a duel; he wounded him, they made friends again, then returned to the café, where the regulars composed a song in their honor.

The outbreak of war in 1870 scattered the Batignolles group, and it was never quite the same again. By the late 1870s, everything was changing. The regulars had shifted their allegiance to the Nouvelle-Athénes in the Place Pigalle, where the great opposition leaders of a generation before had gone to meet—people like Clemenceau (*see page* 129), Nadar (*see page* 28), and Gambetta (*see page* 54). But this time the member of the group doing all the shouting was Degas (*see page* 58), and there were no songs composed in anyone's honor. Many of the leading Impressionists

had dispersed to the countryside (Monet had gone to Giverny), so they just tended to meet at prearranged dinners when they were all in Paris at the same time.

The Irish writer *George Moore* (1852–1933), who joined them at the café, knew it as the "Academy of Fine Arts." Other critics labeled the Batignolles group "Les Japonais," because of the Impressionist fascination for all things Japanese. Either way, the idea of starting new artistic movements in cafés has caught on and has become an integral part of the new mythology of cities.

Edgar Degas, *Portrait of Edmond Duranty* (1879). Duranty's novella *Le Peintre Louis Martin* describes the tension in the Parisian art world at the time.

1866 British engineer Robert Whitened invents the torpedo, an underwater guided missile with a warhead of dynamite.

1870 US property developer William T. Blodgett buys three art collections in Paris, paying $116,180 for 174 pictures, and gives them to New York's Metropolitan Museum.

1880 In *A Tramp Abroad*, Mark Twain lists all the foods he has missed while traveling around Europe; they include terrapin, possum, chitterlings, and buckwheat pancakes with maple syrup.

1865~1917
The Magic of Ankles
Degas

Why was Degas so keen on ballet?

The trouble with Degas is that he was much angrier than the other Impressionists. He didn't share their vaguely revolutionary ideas—quite the reverse, in fact. His views during the infamous Dreyfus scandal (see page 71) were so vitriolicly anti-semitic that he alienated many of his friends, and he always rejected any model who turned out to have Jewish ancestry. But the big idea of painting exactly what you see gripped him as much as it did the others: it's just that it tended to grip him at the theater or circus.

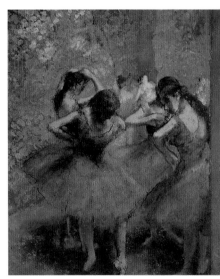

E dgar DEGAS (1834–1917) was one of the prime organizers of the Impressionist exhibitions and was furious when any of the others dropped out to exhibit at the Salon. He introduced Mary Cassatt (*see page* 84)—his great friend and model—into the group, and his name has been linked with those of his Impressionist colleagues then and ever afterward. But, despite all this, he always denied that he was an Impressionist.

There were differences. For one thing, he was rich: he didn't have to endure the appalling poverty that many of the others

Edgar Degas, *Blue Dancers* (c.1893). Most of his ballet pictures featured backstage scenes and were worked up from rapid sketches.

faced. For another thing, he was implacably urban. Not for Degas painting in the wind and rain: heavens no, he wanted to be a dandy, wandering around the Tuileries in his best clothes.

1900 In Beijing, a contingent of foreign troops quells the Boxer Rebellion.

1909 Sergei Diaghilev founds the Ballets Russes in Paris, along with choreographer Michel Fokine and the dancers Vaslav Nijinsky and Anna Pavlova.

1917 Theda Bara stars in the movie *Cleopatra*. Previous, equally vampish roles have included *Carmen*, *Vixen*, and *The Tiger Woman* as well as *Eternal Sappho*.

And for another thing, he was also a sculptor—especially toward the later part of his career; his famous sculpture of a little ballet girl wearing a real tutu (1881) was absolutely shocking, according to contemporary critics. In contrast to the Impressionists, it was primarily movement that fascinated Degas rather than light and color. And he really worked at his canvases. These were no instant impressions tossed off in the moment. "There is nothing less spontaneous than my art," he wrote, indignantly.

But if he was unlike them in many ways, it was because Degas pushed some of their characteristics to extremes. Even more than the other Impressionists, he was influenced by snapshots. His figures are cut off at the edge of the painting, or bisected by pillars and rods like a Japanese print. And even more than the other Impressionists, he was fascinated by cafés, theaters and dance. Over half his pastels and oils are of ballerinas.

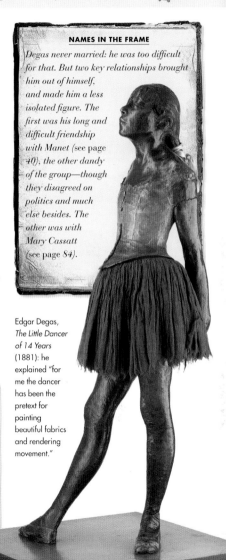

NAMES IN THE FRAME

Degas never married: he was too difficult for that. But two key relationships brought him out of himself, and made him a less isolated figure. The first was his long and difficult friendship with Manet (see page 40); the other dandy of the group—though they disagreed on politics and much else besides. The other was with Mary Cassatt (see page 84).

Edgar Degas, *The Little Dancer of 14 Years* (1881): he explained "for me the dancer has been the pretext for painting beautiful fabrics and rendering movement."

TECHNIQUES

Degas wasn't very interested in sunlight; he preferred the artificial light in cafés. This made him the most experimental of the Impressionists. He tried using far less paint, believing the Impressionists loaded too much on their brushes. He tried using oil paint thinned with turps. He tried removing the oil with blotting paper. He tried layers and layers of pastel, as well as gouache and egg tempera (like the Renaissance artists he had studied at the École de Beaux-Arts). In the end it was for pastels—employed in increasingly broad strokes as his eyesight failed—that Degas would become best known.

1868 In a cave near Périgueux, France, Cro-Magnon skeletons are found that date to 68,000 BC.

1872 In a letter to her daughter, Queen Victoria writes "I don't dislike babies but I find the very young ones rather disgusting."

1891 Thomas Hardy's wife leads the storm of protest about the immorality of his novel *Tess of the D'Urbevilles*.

1868~1926

Petal Power
Morisot

A fateful meeting for all concerned.

There she was sitting in the Louvre, copying a painting by Rubens like a good art student, when Berthe MORISOT (1841–95) had her artistic and love lives changed simultaneously. Her friend Fantin-Latour (see box) introduced her to Manet (see page 40). It was a critical meeting for both of them, and from then on she was a fully fledged Impressionist and the most prominent woman in the group.

Morisot had been the pupil of Corot (*see page 20*), but after meeting Manet and appearing in many of his paintings—see *The Balcony* (1868–9)—she became what one critic described as the "only impressionist of the group." He was referring to her free brushstrokes, her pale grays, blues and yellows, like the flowers that appear in many of her paintings. "She grinds flower petals on to her palette," wrote one critic, "so as to spread them later on her canvas with airy, witty touches, thrown down almost haphazardly."

Balloon mail

Unlike the other Impressionists, and much to the concern of Manet and Degas—who were in the artillery—Morisot remained in Paris under siege for the duration of the Franco-Prussian War. She spent her days writing long letters to her sister, which were despatched from the city by balloon; in them she describes the noise of the artillery, the corpses they found on the streets during their daily walks, and how Manet spent most of his time changing from one grand uniform into another.

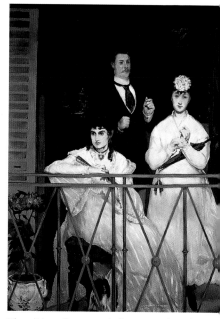

Edouard Manet, *The Balcony* (1868–9): includes Berthe Morisot, his future sister-in-law and fellow Impressionist sitting in the foreground.

1899 Kate Chopin is ostracized by polite society after publication of *The Awakening* in which she describes a woman who is stifling in her marriage.

1908 Suffragettes Emmeline and Christabel Pankhurst are sentenced to jail after a sensational trial in which two cabinet ministers testify in their defense.

1924 Lotte Lenya meets Kurt Weill for the first time at a railroad station and by the time they have rowed across the lake to the house of their friends, they have decided to get married.

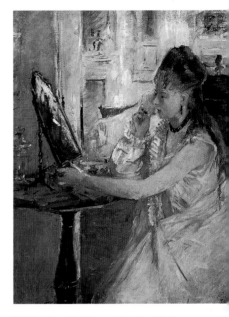

Berthe Morisot, *Young Girl Powdering her Face* (1877): her impressions were intimate scenes set in the boudoir. She has been acclaimed as one of the great forgotten women artists of the 19th century.

The relationship with Manet was a frustrating business. She persuaded him to abandon black in his pictures and to experiment with more Impressionist styles, then—after she became irritated by his obsession with his latest pupil and admirer *Eva GONZALÈS* (1843–83)—she married Manet's brother Eugène. Their house became the intellectual center of Impressionism in Paris, and their daughter *Julie* (1879–1966) wrote a revealing teenage diary, later published as *Growing Up with the Impressionists*, finally translated into English in 1987.

As Manet's sister-in-law, Morisot bound him further into the Impressionist world, but after 1885 she found herself increasingly influenced by Renoir. Yet she had her own individual style too. She didn't cover up her mistakes. Her oil paints look more like sketches, and she wiped and blotted as she went along.

Unlike the other Impressionists, Morisot never painted in theaters and cafés. Her subject matter was wealthy, elegant women getting out of bed, with their children, looking into mirrors, all captured in informal poses—an amazing record of bourgeois life in Paris in the middle of the 19th century. She showed her work very successfully in most of the Impressionist exhibitions, and her painting *Lady at her Toilette* (c. 1875) took the fifth one in 1880 by storm.

> **NAMES IN THE FRAME**
>
> **Henry Fantin-Latour** *(1836–1904) specialized in romantic figures, portraits, and still-lifes, and exhibited regularly in the Salon—but his work also appeared next to the Impressionists' in the Salon des Refusés (see page 52). He was friendly with Manet and Whistler (see page 38), and his painting* Studio in the Batignolles Quarter *(1870) gives a glimpse of Manet, Renoir, Bazille and Monet at work.*

1869

Bathing Beauties
Monet and Renoir at La Grenouillère

Claude Monet, *La Grenouillère* (1869): a leap forward toward Impressionism.

When two young men escape their debts on a series of visits to a popular bathing place in the summer, they don't usually stumble upon a whole new artistic method. But Monet and Renoir did. By the end of the summer of 1869, the basic Impressionist technique had arrived.

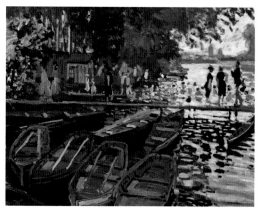

The date was June 1869. Renoir was trying to cut costs by staying with his parents at Voisins-Louveciennes; Monet was living in the first of a number of country homes, at St-Michel near Bougival; and the two of them visited each other nearly every day. Not surprisingly, given their cult of open-air painting, they found themselves at La Grenouillère ("The Froggery"), a bathing place on Croissy Island, just a short walk away from Bougival. A local entrepreneur had moored two barges together, and

Monet's Seine
The point about Monet's paintings of the Seine, which he was beginning to churn out at the end of the 1860s, is that they were informal. These weren't posed paintings as you would find them in the great galleries—which he insisted at the time should be burned down. They were rapid, open-air sketches in oils that capture a moment in time, with everything portrayed just as he saw it.

people spent the summer dancing and dining on them.

Not Renoir and Monet, of course. They were busy trying to capture the shimmering light and color, realizing that shadows aren't colored brown or black but take on the shades around them—and limiting their palettes to the primary colors. By the end of the summer they had banned black and brown altogether.

Check out the results: both Monet and Renoir have paintings called *La Grenouillère*, and at first sight they're

1869 Many Americans are fooled by the Cardiff Man, a giant stone figure found in Cardiff, New York. It is claimed to date from biblical times but is actually a hoax.

1869 In Britain, a new law allows the police to arrest female prostitutes but they can take no action against their clients.

1869 Louisa May Alcott writes *Little Women*, describing her childhood in New England.

pretty identical—the same light on the water, the same sketchlike finished painting. But on closer examination the differences between them are clear. Monet chose a more distant viewpoint so that he could focus on the water—which was always his main fascination. Renoir moved in closer to focus on the people and the long white dresses, which were his chief interest. The differences between the two of them were already set.

Both concentrated on the tiny island—known as Camembert, named because it was shaped like the cheese—though Monet produced two pictures of the footbridge, and Renoir painted one of the footbridge

> **TECHNIQUES**
> Renoir had a revolutionary way of going about painting. Instead of mixing his colors on the palette like most artists before him, he mixed them on the canvas, putting colors next to each other while they were still wet. It explains some of the fuzzy effect he achieves in his work.

and two of the riverbank. It was a good summer's work. It was still five years before the first Impressionist exhibition, but this was probably the moment when the new artistic school had arrived—and all from the challenge of painting a summer scene of sunlight on placid water.

Pierre-Auguste Renoir, *Bathing in the Seine: La Grenouillère* (1869): he was much more interested in people and their activities than the landscape.

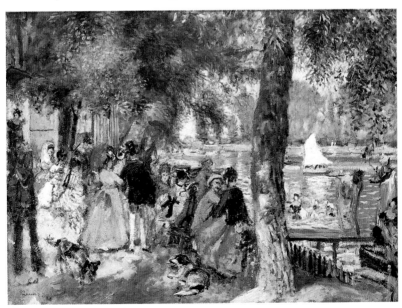

1870 French citizens donate 40 million francs to build the church of Sacré Coeur as a symbol of hope following their defeat by the Germans at Sedan.

1870 William Lyman patents a can opener with a wheel that runs around the rim of the can.

1870 Jules Vernes writes *Twenty Thousand Leagues under the Sea,* about Captain Nemo and his submarine.

1870~1871

Barbarians at the Gate
The Franco-Prussian War

Every generation has its enormous and disruptive historic event, and for the young Impressionists it was the Franco-Prussian War—the tragic result of the vanities of Bismarck (see page 18) and the French Emperor Napoleon III (see page 32). The war was followed swiftly by the bloody aftermath of the Paris Commune in 1871. By the end of May 1871, the Impressionists had been scattered and Bazille (see page 45) had been killed.

Life in exile

Some of the best-known Impressionist paintings by Monet and Pissarro were executed while they were penniless refugees in London. Monet painted his sprawling and atmospheric pictures of Hyde Park and his famous misty picture of Westminster Bridge. Pissarro did his equally famous studies of the Norwood area near where he was living. Both watched the progress of Durand-Ruel's two exhibitions of the Society of French Artists at his ironically named "German Gallery" in New Bond Street, and both had pictures included. Durand-Ruel bought his very first Pissarro, of the Crystal Palace.

The war was the fulfillment of Bismarck's hopes for German unification, and it went downhill all the way for the French, with Napoleon captured at the Battle of Sedan—he died in exile in Kent—and Paris besieged by Prussian troops. "We're beginning to feel the pinch here," wrote Manet to his wife. "Horse meat is a delicacy, donkey is exorbitantly expensive; there are butcher's shops for dogs, cats and rats. Paris is deathly sad. When will it all end?" He wasn't the only one to be asking that.

But after the armistice in January 1871, the republicans in Paris wanted to fight on and they seized control of the city. For two and a half months, the Commune ruled, and they appointed Courbet (*see page* 21) to be in charge of the arts. He abolished the École des Beaux-Arts and banned prizes at

Edouard Manet, *Civil War* (1871–3): a sketch of the aftermath of the Paris Commune, showing the devastation that had been wrought on the city.

1871 In the Arctic, 32 whaling ships are trapped in ice at the end of August when winter comes unusually early.

1871 The American ambassador teaches Queen Victoria to play poker at a party in Somerset.

1871 Heinrich Schliemann begins excavations at the site of the ancient city of Troy but his amateurish methods annoy professional archeologists.

Firing squad

It was in 1869 that Manet fought his bitterest battle with the censors at the Salon, when they rejected his revolutionary painting of the execution of the Maximilian, Emperor of Mexico, who had been shot in 1867. The subject of the painting was pretty inflammatory in itself for a left-wing republican like Manet—Berthe Morisot's mother (*see page* 60) used to call him "that communist." In the end he produced three versions, but the finished painting (1868–9) shows the soldiers of the firing squad in French military uniforms, Manet's way of making a political point. In 1871 the Commune included Manet in its revolutionary federation of 25 artists,

and he was determined to protest against the suppression of the Communards with a major work but he only managed a handful of lithographs and sketches. See, for example, his *Civil War* (1871–3) and *The Barricade* (1871).

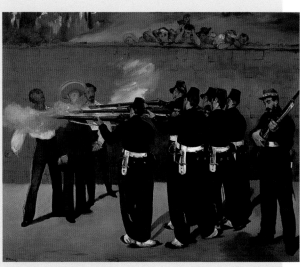

Edouard Manet, *The Execution of Maximilian 1867* (1868–9): his controversial magnum opus.

the Salon. When French troops arrived at the end of May and slaughtered 20,000 of the Communards, Manet was there with his sketchbook (*see* box).

Meanwhile, Bazille and Renoir were called up; Manet and Degas joined the artillery—even though Degas was almost blind in one eye. Cézanne escaped south to avoid conscription. Cassatt went home to the US. Morisot stayed put in Paris. Monet and Pissarro didn't feel like fighting for an imperial government they despised and

escaped to London; while there they met the art dealer Paul Durand-Ruel (*see page* 66), who was destined to play a key role in the lives of the Impressionists.

When Pissarro got home, he found that Prussian troops had stolen or destroyed most of his work. Nobody is quite sure what happened to Sisley, who wasn't French, but it seems likely that he spent time in Paris with his dying father—who left him nothing in his will. The Impressionists were temporarily scattered.

1875 Boss Tweed's New York Courthouse costs millions and it is found that his cronies have been overcharging: one bill for a day's work by a carpenter comes to $361,000.

1889 Helena Rubinstein leaves Poland aged 19 to look for a husband in Australia. Within three years, she has made $100,000 selling a face cream made from tree bark and almonds.

1891 New York's Carnegie Hall opens and Tchaikovsky appears as a guest conductor on the opening night.

1870~1914

Death of a Salesman
Durand-Ruel

Pierre-Auguste Renoir, Portrait of Paul Durand-Ruel (1910): the dealer, painted by an artist who was often unfaithful to him.

Never was one art dealer so crucial to a new movement in modern art, and never have the artists behaved so ungratefully towards him. Yet without Paul DURAND-RUEL (1831–1922), and without Monet and Pissarro's crucial meeting with him in London during the Franco-Prussian War, Impressionism would probably have taken much longer to earn its keep. Maybe it wouldn't have made it at all.

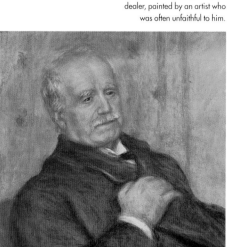

Durand-Ruel was the son of a stationer who often accepted paintings from impoverished artists in return for brushes and paints. When Paul inherited the business in 1865, he started selling pictures by Courbet, Delacroix, Corot, and Daubigny (*see page* 20). It was Daubigny who introduced him to the Impressionist refugees in London in 1870. For the rest of his life, he devoted his enormous energy to establishing their movement, selling their work—and making a great deal of money as a result.

His techniques were excellent PR, coverage in glossy magazines, bidding up Impressionist work at auctions, and sending their paintings abroad for high-profile exhibitions all over Europe. It was hard going at first, but it worked.

The trouble was, the Impressionists didn't really appreciate it. They kept abandoning him for other dealers and, worse, trying to sell their paintings direct

1898 In the Spanish-American War, more US troops die from eating contaminated meat than from wounds received in battle.

1912 The British explorer Captain Robert Scott reaches the South Pole to find that Norwegian Roald Amundsen had beaten him by a month.

1914 Paul Bunyan and a blue ox called Babe appear in advertisements for the Red River Lumber Co.

to avoid his commission. "I was weak enough to be unfaithful to you on several occasions, but I have had enough of collectors and I will not let myself be persuaded again," lied Renoir in 1901.

You can't help feeling sorry for Durand-Ruel—but while he made the Impressionists' fortunes, they made his as well. He died at the age of 91, a very wealthy man who had been awarded the French Legion of Honor. But no matter how critical he was to the movement, his name is rarely whispered alongside those of Monet, Renoir, or Pissarro. It wasn't until 1970 that a major exhibition was held in New York, entitled "A Hundred Years of Impressionism: A Tribute to Paul Durand-Ruel." It was belated recognition of his central role in the movement.

> **NAMES IN THE FRAME**
>
> By the time the Impressionists were churning out their paintings, there were international railroads, reliable international post, new techniques for reproducing photographs—and that meant, for the first time, the modern phenomenon of international art exhibitions. A network of dealers spread the Impressionist word across Europe, starting with a major exhibition in Belgium in 1883. Impressionist artists took part in the controversial international exhibition sponsored by the Kaiser in Berlin in 1895—much to the fury of French nationalists. And in 1897, the first Impressionist painting reached Russia: Monet's Lilac in the Sun (1873).

Claude Monet, *Lilac in the Sun* (1873): the first Impressionist painting to reach Russia. At the Pushkin Museum in Moscow.

To the US
In 1886 Durand-Ruel took Impressionism to the US. America wasn't sure. "One of the greatest stumbling blocks in the Impressionist work ... was the prevalence of violet shadows," wrote one of the few good reviews. "In considering this, it must be remembered that there are more violets in the shadows in many parts of France than in this country."

IMPRESSIONIST ART ~ A CRASH COURSE **67**

1874 Thousands of Mennonites from Russia's Crimea arrive to set up home in Kansas.

1874 At Christmas, Macy's display their doll collection in the shop windows, beginning a tradition which other stores will follow.

1874 The game of lawn tennis is patented by Major Walter Wingfield, but he gives it the extraordinary name of "Sphairistike."

1874

First Impressions
The 1874 exhibition

They say a prophet is without honor in his own country and after the financial and public relations disaster of the very first Impressionist exhibition in 1874, the artists must have felt a bit like prophets. But the disaster achieved something that nothing else could have done: it forged them together as a group, and it gave them a name. The trouble was, it was a name that started as an insult.

The exhibition began after another brutally conservative selection by the Salon in 1873 and another Salon des Refusés for rejected artists (*see page 52*). But joining that kind of artistic protest just gives your work the stamp of rejection.

So instead, the regulars at the Café Guerbois formed themselves into the Société Anonyme des Artistes (a limited company, in other words) and organized their own exhibition.

The 165 pictures included works by Monet, Morisot, Degas, Renoir, Pissarro, Cézanne, Sisley, Boudin (*see page 27*) and Guillaumin (*see box*), among others, and were hung on red wallpaper by Renoir. He was supposed to be chairing the hanging committee, but the other committee members never turned up. Many other artists were included as well, most of them recruited by Degas.

Their exhibition opened three days after the Salon show on April 15 at 35 boulevard des Capucines, in a studio just vacated by the photographer Nadar (*see page 28*). It lasted a month, and remained

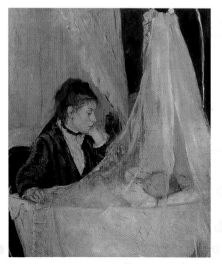

Berthe Morisot, *The Cradle* (1872): one of the more popular pictures shown to the Parisian public at the 1874 exhibition.

1874 The first bridge to span the Mississippi at St. Louis is tested before it opens: seven locomotives chug across in each direction, weighing 700 tons altogether, but the bridge holds up.

1874 Verdi's *Requiem* premieres in Milan. He has written it in memoriam for Alessandro Manzoni, the Italian poet and playwright.

1874 The Women's Christian Temperance Movement is founded in Cleveland to try and stop the traffic in liquor.

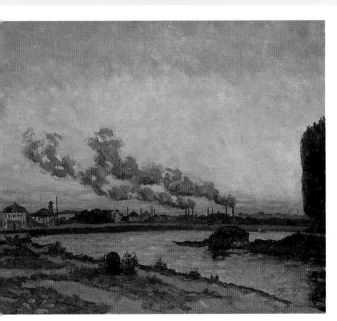

Armand Guillaumin, *Sunset at Ivry* (1873). Impressionists often included factories in their landscape—the world as it really was.

Harsh words

This is how the anonymous critic of the newspaper *La Patrie* described the exhibition: "Looking at the first rough works—and rough is the right word—you simply shrug your shoulders; seeing the next lot, you burst out laughing; but with the last ones you finally get angry. And you are sorry you did not give the franc you paid to get in to some poor beggar."

open until 10pm as a gesture toward the working classes. It was a commercial failure: 3,500 people paid one franc to come and see it; many of them were buyers, but many of them were also critics, and most of them absolutely hated it.

Monet's painting *Impression: Sunrise* (1872–3) aroused the most rage of all, and it led to the famous article in the satirical magazine *Le Charivari* headed "The Exhibition of the Impressionists." It was the first time the word had been coined. The collective heading by which the group went down in history began thus, as a cynical sideswipe by a critic. Other critics didn't even bother with wit: they just slammed it.

NAMES IN THE FRAME

One of those who took the risk of showing his work in the first exhibition—and it was a risk in that artistic climate—was to be the longest-lived of all the Impressionists. **Armand Guillaumin** *(1841–1927), a former railroad worker, met Cézanne and Pissarro at the Académie Suisse. He was particularly influenced by Cézanne, and later in life produced pictures that were more like the works of the Fauves ("wild beasts"; see page 123), a group which included Matisse and Derain. See his* Portrait of Pissarro Painting a Blind *(c. 1868) and* Sunset at Ivry *(1873).*

1875 50 million cigarettes are produced in the US.

1894 Bernard Berenson writes *The Venetian Painters of the Renaissance*, establishing himself as the leading authority on Classical art.

1902 Morris Michtom and his wife produce the world's first "teddy bear," inspired by President "Teddy" Roosevelt's refusal to shoot a bear while out hunting.

1874~1941

Grim Reapers
Impressionist writers

They were a miserable gang, the contemporary French writers. "You are a happy man," wrote Baudelaire to a friend. "I feel sorry for you for being happy so easily. A man must have sunk low to consider himself happy." Maybe they were miserable because that was the "correct" artistic attitude to the dull, conservative empire of Napoleon III and the dull, conservative republic that followed it. Maybe it was because they kept being tried for offending public morals. But maybe it was also because French writers were miffed at being overtaken by artists as the pre-eminent creative force of the age.

Charles Baudelaire: the central figure in a new literary movement that would back the Impressionists just before his death.

If so, that wasn't the whole story. Because it was the poet *Charles BAUDELAIRE* (1821–67) whose brilliant works of art criticism proposed the idea of a "realistic" art to portray modern life as it really was. And it was the writer *Emile ZOLA* (1840–1902) who defended the Impressionists when the whole world seemed against them.

Zola was among those arguing well into the night at the Café Guerbois, and he championed the cause of his friends in his controversial column in the newspaper *L'Evenement*—at least until he finally attacked Manet in print in 1879, accusing him of being "satisfied with approximations." "For this reason it is to be feared that they are merely preparing the path for the great artist of the future expected by the world," wrote Zola. He may well have been right.

1917 General Edmund Allenby leads British troops into Jerusalem, and Balfour declares that he favors the establishment of a national home for Jews in Palestine.

1922 Irish revolutionary Michael Collins of Sinn Fein who object to a peace treaty he's drawn up with the British.

1941 President Roosevelt establishes the Manhattan Project to build an atom bomb. General L.R. Groves is put in charge and he chooses Robert Oppenheimer to direct a laboratory at Los Alamos.

Zola never shrank from confrontation. His famous letter *"J'accuse"* in 1898 blew the lid on the Dreyfus Affair, in which a French artillery officer had been unjustly imprisoned for treason in a burst of anti-semitism. Zola's series of twenty novels, *Les Rougon-Macquart* (1871–93), didn't shrink from social reality any more than the Impressionist painters did: one was about prostitution, another about alcoholism and much else besides. His colleague Gustave Flaubert (*see page* 25), who was prosecuted for *Madame*

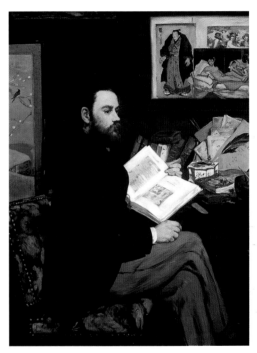

Edouard Manet, *Emile Zola* (1868): a portrait of his friend looking distinguished and very literary. Painted in the years before they argued, when they still spoke to each other.

NAMES IN THE FRAME

*If ever there was an Impressionist poet, it was **Stephane Mallarmé** (1842–89), who founded a genre known as Symbolism, which was musical, experimental, not very grammatical, and completely obscure. Like Baudelaire, he spent much of his time translating the writing of the American **Edgar Allan Poe** (1809–49). But his poems are trying to achieve what Monet was doing with paint—be a completely objective communication of fleeting moments ("O the jocund day/Stands tiptoe on the misty mountain tops" etcetera). There would be a great deal more where that came from.*

Bovary (1857), also considered writing Impressionist novels with no subject. And although he might not have dared do it himself, the idea was taken up by some enthusiastic young writers around him (*see* box), and spread to some highly important luminaries elsewhere, including James Joyce (*1882–1941*).

1875 John Warner Gates, otherwise known as "Bet you a million" Gates, demonstrates the safety of barbed wire by creating an enclosure of cattle in the middle of San Antonio.

1875 The *Great Chac-Mool* limestone figure from the Maya-Toltec civilization of the 10th to 12th centuries AD in the Yucatán is discovered at the entrance to a temple at Chichén-Itzá.

1875 As he listens to an assistant plucking a spring in the attic of his electrical workshop, Alexander Graham Bell realizes how he is going to be able to make telephones work.

1875~1876

Rather Sodden People

The Absinthe Drinker

Absinthe was de rigeur for the world-weary French bohemians and decadents. If you drank too much of the gin-based liqueur—originally flavored with the herb wormwood—you got to be a very sad person indeed. That was one of the shocking things—though only one—about Degas' picture The Absinthe Drinker *(1875–6), which incurred the rage of the critics when it was first shown in London in 1893.*

It was given a range of different names, starting with "Dans un Café," and in England—where it was sold—"A Sketch in a French Cafè." It shows a particularly

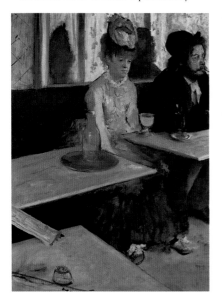

Edgar Degas, *The Absinthe Drinker* (1875–6). They were especially shocked by it in London.

miserable-looking woman—far too miserable to pick up her drink—next to a particularly disreputable man. In fact they were Degas' friends the actress *Ellen ANDRÉE* (1857–c. 1915) and the engraver *Marcellin DESBOUTIN* (1823–1902), who was a teetotaller. It was a portrait of urban despair.

Absinthe had become popular in France during the 1830s and 40s when

Prices

The prices the Impressionists were able to command have grown steadily since the early days, but they started very low indeed. When the dealer Père Tanguy (1825–93) first started selling Cézannes in 1875 they went for 50 francs each. At the Hôtel Drouot sale in 1877 (*see page* 80), Renoir sold 15 paintings for a total of 2005 francs. The only painting sold at Monet's 1880 exhibition, *Floating Ice on the Seine* (1880), went for 1500 francs. Ten years later Monet collected nearly 20,000 francs to buy Manet's *Olympia* (*see page* 54) for the nation. By 1908, Renoir's *Bathing on the Seine* (1869) changed hands for a similar amount and prices began their inexorable rise.

1875 Bosnia and Herzegovina rise against the Turks; the sultan Abdul Aziz promises to give in to their demands and pass some reforms.

1876 Thomas Lipton has two fat pigs painted with the words "I'm going to Lipton's, the best shop in town for Irish bacon" then he parades them all over the streets of Glasgow.

1876 *Roderick Hudson*, the first novel by Henry James, tells of a young man who is transplanted from Massachusetts to Rome and finds himself incapable of adjustment.

TECHNIQUES

The poor woman is dead center, but the composition is a bit peculiar. It's seen from the side, and it looks as if the real action in the room is happening elsewhere. If it has the appearance of a photograph, that isn't any coincidence, because Degas was fascinated by the way photos and Japanese prints cut people off at the frame.

it was prescribed to troops fighting in the Algerian War. By the 1870s its image was entrenched as the drink of those beyond society. Zola (*see page 70*) described its horrific effects in his novel *L'Assommoir*, which he was writing at the same time as Degas was finishing the painting. Its sale and manufacture was made illegal in France during the First World War, though it is now available on the Internet.

Absinthe was the great bohemian drink of the era. It is a pale green color that becomes cloudy when diluted with water, and is highly alcoholic.

Degas found the picture difficult to finish. He had intended it to be ready for the second Impressionist exhibition in 1876, but it wasn't. It went into the third one, in a special room devoted to café scenes, and by then had been sold (*see* box). But its real impact was in London, where it was shown in an exhibition in the Grafton Galleries later that same year.

It was a picture, said the *Westminster Gazette*, of "two rather sodden people." Other magazines said it was depraved, loathsome, revolting and boozy—and certainly it isn't the kind of picture where the heart leaps with excitement at the joy of life. In fact, it probably feels as it was intended—a bit like an absinthe hangover. But it did show urban life as it really was: that was what they intended.

NAMES IN THE FRAME

Degas *sold the painting to a tailor in Brighton called Henry Hill and it was shown for the first time in the Brighton Museum, then borrowed back for the third Impressionist exhibition. When it was sold on at Christies' in London in 1892, the audience actually hissed. It was eventually left to the Louvre in 1911 and can now be seen in the Impressionist collection at the Musée d'Orsay in Paris.*

The audience aren't impressed.

1875 German embryologist Oscar Hertwig finds that the female egg is penetrated by a single male sperm cell.

1877 There are anti-Chinese riots in San Francisco and 25 Chinese wash-houses burn down but the police do not intervene.

1880 Immigrant Samuel Bath Thomas introduces English muffins to New York.

1875~1886
Squabbling Daubers
The next seven exhibitions

It wasn't exactly the Renaissance. After all that effort developing a scheme, you'd have thought the Impressionist artists would have stuck at it for a century or so, if only because they had finally forged themselves together into a cohesive group to face down the wrath of the critics. But no: the so-called period of "High Impressionism" only really lasted seven years, from the first exhibition in 1874 until 1881.

TECHNIQUES
The real reason for their differences was that they had very different techniques. The approach to colors discovered by Chevreul (*see page 22*) was one thing they had in common. So was painting out of doors or on the spot, but even then they weren't strict about it. And there was an emphasis on immediacy.

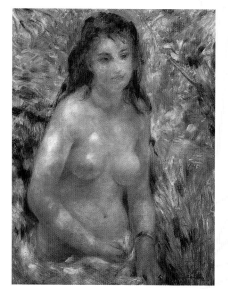

Pierre-Auguste Renoir, *Female Nude in the Sun* (1876). He played a key role in the first show but refused to take part by the fifth one in 1880.

What went wrong? Well, partly it was problems with developing the technique further. It seemed to require something more—and exactly what that something more might be ended up dividing them in all directions. But partly it was also because the next seven Impressionist exhibitions in Paris—starting off with nearly one a year and then dwindling—ended up infuriating them all with each other.

They barely made a profit. The critics kept up a constant barrage of ridicule. Cartoons appeared of armies frightening the enemy with Impressionist paintings. "But these are the colors of a corpse," says the critic in one cartoon in *Le Charivari*, quoting the words a critic had written about one of Renoir's nudes. The painter replies: "Unfortunately I can't get the smell." It wasn't very easy being an Impressionist in the 1870s.

1883 Robert Louis Stevenson's *Treasure Island* features the pirate song "Fifteen men on a dead man's chest/ Yo-ho-ho and a bottle of rum."

1885 Spain's King Alfonso XII dies of tuberculosis after surviving two assassination attempts.

1886 Door-to-door salesman David McConnell sets up Avon Products: he has been selling books by offering free perfume to customers but he soon realizes they are more interested in the perfume than the books.

The inclusion of Caillebotte (*see page 32*) in the second exhibition in 1876—his *The Floor Strippers* (1875) was the hit of the show—brought the public in, but set in motion the difficulties that would tear them apart. It was at a dinner party hosted by Caillebotte before the third exhibition in 1877 that they agreed on rules to tighten the group around the exhibition—which Renoir promptly broke by exhibiting in the Salon. Degas developed a stranglehold over the organization and by the fifth exhibition in 1880, Monet, Renoir, Sisley and Cézanne refused to take part at all.

They flocked back for the seventh exhibition in 1882, after Durand-Ruel (*see page 66*) saved the day by organizing the whole business himself. But the last one of all, four years later, was even more fractious than before—mainly because the new guard was included (*see page 92*).

NAMES IN THE FRAME

In 1878, Monet was at rock bottom. He was too poor to pay the fee to exhibit in the fourth Impressionist exhibition. In September, his wife Camille died. His patron, the department store owner **Ernest Hoschede** *(1838–90) had gone bankrupt, and his family had moved in with the Monets. Not surprising, perhaps, that Monet later married Hoschede's wife. Meanwhile he was too angry with his fellow Impressionists to get much out of his friends: "The little church has become a banal school which opens its doors to the first dauber," he said scathingly.*

Gustave Caillebotte, *The Floor Strippers* (1875): the crowd pleaser at the second Impressionist exhibition in 1876, although Zola was one of the dissenting voices. Soon after, Caillebotte turned to boating scenes.

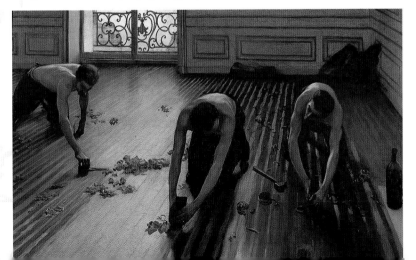

1875 The first roller skating rink opens in London's Belgravia.

1888 Jack the Ripper kills and disembowels five female victims this year in the East End of London.

1890 Sir James Frazer produces *The Golden Bough*, a compendium of world mythologies.

1875~1914

The Starving Garret
Bohemianism and decadence

Those weird artists—goodness knows what they get up to! Sitting up to all hours drinking absinthe and arguing in cafés. It wasn't just their paintings that shocked the public: the Impressionists were shocking by their mere existence—because of their poverty, their dresscode, their unreliability and their radical views.

But actually, it wasn't very fair. It was the previous generation, people like Courbet (*see page 21*), who had been the original bohemians—deliberately flying in the face of public taste, or pulling down columns in Paris during the Commune.

Compared to them, the Impressionists were mild-mannered. They may have dressed badly and insisted on working outdoors, but they weren't very interested in politics and—generally speaking—they were faithful to their husbands and wives.

Still, they were the first generation of urban bohemians, far more at home in Paris than in the wind and the rain with people like Courbet and Daubigny. And

NAMES IN THE FRAME

Big divisions were beginning to emerge between the bohemian Impressionists and Degas' decadent "gang" of café society cronies, including the realist painter **Jean-François Raffaelli** *(1850–1924) and the Italian pastel artist* **Federico Zandomeneghi** *(1841–1917). The more successful the gang became, the less the Impressionists liked them.*

Federico Zandomeneghi, *Preparing to Go Out* (1894): one of Degas' café "gang" who shared his friend's interest in women.

1894 Edison laboratories in West Orange, New Jersey copyright their film of a man sneezing straight at the camera.

1901 Britain annexes the Ashanti region and attaches it to its Gold Coast Colony. In 1957 Ashanti will become part of Ghana.

1914 In his poem "Mending Walls," Robert Frost writes "Good fences make good neighbors."

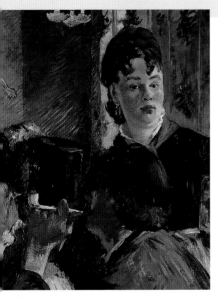

Edouard Manet, *The Waitress* (1878–9): an implacably urban scene. Compare her with the barmaid at the Folies-Bergère (*see page* 96).

"naturalism" and it was a little shocking for the general public—ungodly even. The artists didn't care if people couldn't understand it (and increasingly people couldn't). They were just faithfully recording what they saw.

Take a look at Manet's painting *The Waitress* (1878–9). Her hands are full with beer glasses, and she is looking across to where a customer is shouting at her. It's a picture of distracted, separate city life, shown exactly as it was in the moment— the very essence of Impressionism.

although they didn't look down their noses at country people—or people who were happy—as Baudelaire and his friends did (*see page* 70), they knew where they belonged. Their place was painting in theaters or bars or in the Parisian streets.

Like bohemians, they separated themselves from ordinary life—and not just because of the mauling they received at the hands of the critics. The whole idea of Impressionism was to step back from the scene and just record it, fleetingly and unflinchingly, like Monet. This was what they called

Oscar Wilde as seen by *Vanity Fair*: more decadent than bohemian. He wrote, "To love oneself is the beginning of a lifelong romance."

Decadents

Baudelaire was the role model for a whole new kind of world-weary, miserable bohemianism and, by the 1880s, people were calling it "decadence." It was intoxicating, self-destructive, and refined in its taste—and it flew in the face of the despised public. Degas and Manet adopted the dandy style, and it also surfaced in England with Whistler and his friend Oscar Wilde (*see page* 124). Decadence ultimately destroyed Wilde, the author of *The Importance of Being Earnest*: the public turned on him after he was prosecuted for homosexuality and sentenced to a term in jail with hard labor.

1876 Henry Wickham smuggles some rubber plant seeds out of Brazil and gives them to Kew Gardens, which donates some to Ceylon, India, and Malaya, thus ending Brazil's monopoly on rubber.

1876 In Vienna, Gebruder Thonet designs a bentwood hardback chair, which will become the standard type found in restaurants and cafés for almost a century.

1876 Wild Bill Hickok is murdered while playing poker. He is holding two pairs, aces and eights, which will become known as the "Dead Man's Hand."

1876

Tangled Bodies
Dancing at the Moulin de la Galette

Watching Sunday afternoon at the Moulin.

I may not know about art, said the public—once they had finally been cowed into submission by modern artists—but I know what I like. And with the intoxicating joie de vivre in Renoir's masterpiece Dancing at the Moulin de la Galette *(1876), the controversial Impressionists had at last produced something that everyone seemed to like. No matter how much the public and the critics raged at Impressionism, they always loved this one.*

In fact, the painting was given a place of honor in the third Impressionist exhibition of 1876 and dominated the comment about it. "It is like the shimmer of a rainbow," said *Le Courrier de France*. And it is. Many of the faces are recognizable as Renoir's friends, and they seem to be universally happy. There is a great deal of red lipstick around, and rather a lot of eyeshadow.

It's an intoxicating picture which seems to stretch back into the distance, and gives a kind of movement and flow to all the people gathered together. The dappled sunlight—what one critic called "purplish clouds"—hold it together. And so does the universal enjoyment. This may be a picture of modern life, but it misses out the dark bits. People weren't allowed to be miserable in Renoir's pictures and the sun was usually shining.

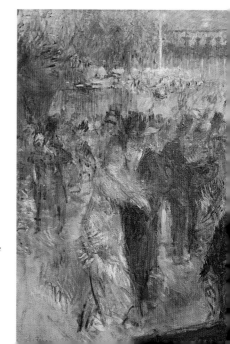

1876 Foil-wrapped bananas are sold at a fair in Philadelphia. Most people have never tasted them before.

1876 American inventor John McTammany demonstrates a player piano that makes music mechanically from perforated paper rolls.

1876 American Lydia E. Pinkham markets a vegetable compound that is said to cure "woman's weakness" and all related ills.

Light box

The picture shows one of the Moulin's regular Sunday afternoon dances. They started at 3pm and went on until midnight and when it got dark, the white lamps shown in the picture were lit. But unlike Degas, it was the play of sunlight that Renoir was interested in—not the artificial evening light. It's an important distinction. Degas' faces are often lit powerfully from the side or from behind, giving a moody, atmospheric melancholy. Renoir's tend to glow with the sort of sunlight that filters through trees. Renoir was no pedlar of urban despair.

Pierre-Auguste Renoir, sketch for *Dancing at the Moulin de la Galette* (1876). The finished painting was sold 71 years after Renoir's death for a mere $78.1 million (*see page 137*).

Renoir had rented an apartment near the Moulin—a real windmill turned into a café and dance hall in Montmartre—just to paint the picture. Montmartre wasn't the trendy place it was shortly to become, so these are mainly working men and women taking part in the most popular Parisian leisure activity of the late 19th century: dancing. (In case you were wondering, *galette* means "small pancake.")

Renoir's biographer *Georges RIVIÈRE* (1855–1943)—who is the dappled man with the purple spots in the foreground (check out the woman glancing at him from the middle of the picture)—said that Renoir painted it on the spot in true Impressionist style. But there are preliminary sketches in existence and it is pretty vast, so we can safely assume he finished it off in the studio.

After the exhibition, the painting was bought by Caillebotte (*see page 32*), and became part of the controversial Caillebotte Collection left to the nation after his early death, and the object of legal wrangling for the next two decades. It is now shown at the Musée d'Orsay in Paris.

TECHNIQUES

One of the reasons for the red cheeks and lipsticks was the firm Impressionist policy of sticking to bright reds, blues and yellows. Renoir chose specific shades which draw the picture together. He wasn't very interested in form—he just suggested it with quick brushstrokes and flashes of color. It was, after all, the movement he was trying to convey. The yellow splodges of sunlight across the canvas help to capture the energy of the scene.

1877 Thomas Edison demonstrates a hand-cranked phonograph or speaking machine. He recites "Mary had a little lamb" and the machine plays it back again.

1877 A Swedish engineer invents a centrifugal cream separator which will reduce the cost of producing butter.

1877 "Don't jump!" Anna Karenina collides with a train in Tolstoy's epic.

1877
Smoke and Mist
Gare Saint-Lazare

When the Impressionists set off for a jaunt with palette and brushes to Argenteuil on the Seine—their favorite spot, and the place where Monet had his floating studio (see page 27)—they took a 15-minute train ride from the Gare Saint-Lazare in Paris. This was the gigantic terminus built for the first railroad line into Paris in the 1830s, and as such a symbol of the modern life the Impressionists wanted to portray.

Monet's picture *La Gare Saint-Lazare* was one of a series—railroad stations became something of a theme in the third Impressionist exhibition in 1877—and seems to focus more on the smoke coming from the engines than anything else.

This is no coincidence. The painting arose out of Monet's irritation with the critics who claimed that fog wasn't a proper subject for a painting. He decided to go further. He therefore dressed in his best clothes, and set off to the local station with his easel, introducing himself to the superintendent of the line as "the painter Claude Monet." The superintendent wasn't sure about this but he was taking no chances. He cleared the platforms, ordered

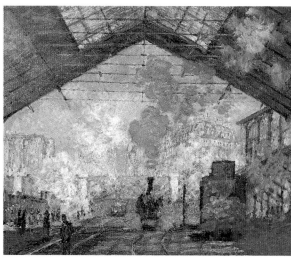

Claude Monet, *La Gare Saint-Lazare* (1877): critics questioned whether steam was a proper subject for an artist to be painting.

the engines to be stuffed full of coal so they would give off more smoke and allowed Monet the run of the place, bowing to him respectfully when he finally left.

1877 The Satsuma Rebellion erupts in Japan after samurai are denied their pensions and forbidden to wear two swords.

1877 The ballet *Swan Lake* premieres at Moscow's Bolshoi Theater with music by Tchaikovsky but the production is not a success.

1877 In London, Charles Bradlaugh and Annie Wood Besant are tried for republishing a book that advocates contraception; their acquittal is an important legal precedent.

Gustave Caillebotte, *Le Pont de l'Europe*, (1876): a dog is apparently the central subject matter.

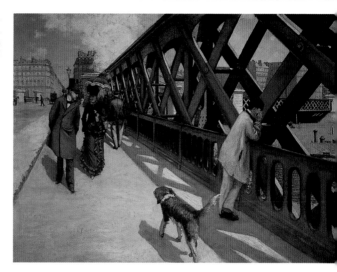

Two bridges

Just before Monet completed *Gare Saint-Lazare*, both he and Caillebotte (see page 32) were painting the same Parisian bridge—the Pont de l'Europe. But Caillebotte's *Le Pont de l'Europe* (1876) isn't really the result of an immediate impression—in fact it is dominated by some very un-Impressionist perspective. What's more, the man in the top hat is supposedly a self-portrait of the artist.

All the superintendent's bowing and scraping certainly paid off, the result is a steamy masterpiece, and just what the Impressionists claimed to do: it was a portrait of modern life as it really was. And it certainly makes the most of the smoke: Monet has even scraped away some of the paint so you can see the white canvas underneath just to give it that extra special impression. There are even one or two railroad engines included for good measure, just in case we didn't realize it was a station. "It's a pictorial symphony," said one critic.

The Impressionists loved steam engines, and painted them over and over again. Have a look at Monet's *Train in the Countryside* (c. 1870–1) or Pissarro's *Lordship Lane Station, Dulwich* (1871), which he painted near where he lived in Norwood, south London, during the Franco-Prussian War (*see page* 64).

Commuters

Argenteuil, Bougival, Marl and Pontoise—the center of the Impressionists' world—were all accessible from Gare Saint-Lazare, near the Batignolles district where they felt most at home in Paris. They were the first suburban generation of artists, commuting backward and forward between the city and countryside that were linked together by railroad stations. Stations were a constituent part of their everyday lives. No wonder the Impressionists kept painting them.

1877 Anna Sewell writes the hugely popular *Black Beauty* and is paid £20 for her efforts; she never gets any royalties.

1877 *The Washington Post* rolls off the presses and is read over breakfast for the very first time.

1877 The first lawn tennis championship is held at Wimbledon and won by Englishman Spencer Gore.

1877~1878

The Pot of Paint
Ruskin versus Whistler

Normally the angry clashes between critics and bitter artists don't end up in court. And when they occasionally do, the whole embarrassing business is usually brushed under the carpet as quickly as possible. But suddenly, out of the blue, there was a courtroom battle that became crucially important in the history of art. The great libel action in London between Ruskin and Whistler (see page 30) also settled an important Impressionist debate—whether it matters how fast you create your painting—in legal terms, at any rate.

It all began with Whistler's controversial and Impressionistic painting of fireworks on the Thames, which he insisted on calling *Nocturne in Black and Gold* (1877; also known as *The Falling Rocket*). The whole idea of the painting enraged the greatest art critic of the age, John RUSKIN (1819–1900), who accused Whistler of "flinging a pot of paint in the public's face." Whistler sued him for libel.

When the case came to court, and Whistler was cross-examined, the debate turned on how long it had taken him to paint it and how much he hoped to sell it for. Whistler turned the tables on the barrister by asking him the same question: how long had he taken to prepare for the case and what was he charging per hour?

James A. McNeill Whistler, *Nocturne in Black and Gold* (1877): the painting that caused all the trouble. *See pages 38–9 for earlier examples of his painting.*

1878 The first sleeping bag is made in France for Scottish writer Robert Louis Stevenson.

1878 Louis Comfort Tiffany establishes a factory in Queens, New York to make specialist glassware.

1878 Britain occupies Cyprus after agreeing with the Turkish sultan to protect Turkey from attack.

Ruin

The libel action was a financial disaster for both Ruskin and Whistler. For Ruskin it was another twist on the slow, downward path to insanity. For Whistler, it all but bankrupted him—and he escaped to Venice to raise money by doing the only things he knew he was a master at: a series of etchings. As in almost all libel cases, the only people who benefitted were the lawyers.

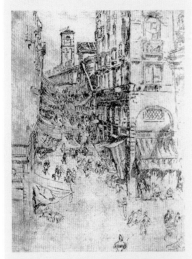

James A. McNeill Whistler, *Venice, The Rialto* (1878): an etching he created to help pay his legal bills. For a while, he eschewed color and heavy lines in favor of delicate sketches.

It was a neat move from the great *flâneur*. It won him the case—though he was awarded only a halfpenny's damages—and it demonstrated finally that artists were no different from other professionals: it wasn't the time they took over the painting that mattered, it was their experience and the insight they brought to

it. It was exactly the point the Impressionists were trying to make on the other side of the English Channel.

Instant impressions, snapshots and fleeting moods were the very stuff of Impressionism. It might not take Monet long to toss off a canvas, but it took him a lifetime to practice doing it until he had enough skill to capture that extraordinary moment. It was official: art couldn't be judged in the way the old conservative Salon judges did—by the amount of time and care that went into its production.

This was a turning point that finally transformed artists from craftspeople into professionals in the eyes of the world. Of course, it took a lot more than an English court case to convince the stubborn French critics, but the dye was cast.

NAMES IN THE FRAME

The case marked a crucial milestone in the development of what would later become known as the Aesthetic Movement—a kind of camp Impressionism gone to seed that attracted artists as widely varied as **Whistler, Edward Burne-Jones** *(1833–98),* **Frederic Leighton** *(1830–96), and* **Aubrey Beardsley** *(1872–98).*

It would be the artistic movement of the end of the century, the fin de siècle.

It was world-weary, urban, decadent and completely passive, and its interpretation of beauty was deliberately obscure and provocative (see page 124).

1877 It is seen as a landmark in international trade when the first shipment of frozen meat reaches Britain from Argentina.

1887 Louis Keller publishes the first social register in New York. To get in, you must be white, non-Jewish, not divorced, and respectable.

1891 Gauguin sails for the South Seas, living first in Tahiti and then in the Marquesas Islands.

1877~1926
The American Connection
Cassatt

Cassatt considers Degas' latest likeness.

Few people really believe that Mary CASSATT (1844–1926) was the mistress of Degas but they certainly became lifelong friends after they met in 1877, and he certainly infuriated her with his constant slighting remarks. His paintings of her in the Louvre aren't very flattering. But in one of his notebooks there's a list of paintings he plans to submit for one of the Impressionist exhibitions, and alongside it is a list of her submissions, which is an intimate touch if nothing else.

D egas was a convinced misogynist, so relations with women were usually a little fraught. Cassatt posed for him over and over again, despite the fact that he described one of his paintings of her as a depiction of "a woman's crushed respect and absence of all feeling in the presence of art." But she shunned him for several years after he made an unpleasant remark about one of her paintings.

Art sales

Cassatt was also important to the Impressionists as a dealer. She bought their paintings and encouraged other Americans to do so, even helping out Durand-Ruel in his tougher moments (*see page 66*). In 1878 there was a disastrous sale at the Hôtel Drouot, when three Renoirs went for the knockdown price of 157 francs, so Cassatt stepped in and bought a Monet and a Morisot to buoy them up. It was her friend Louisine Waldron-Elder who lent Degas' *Ballet Rehearsal* (1876–7) to the American Watercolor Society, the first time his work was seen in the US.

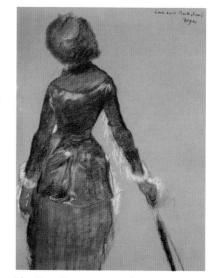

Edgar Degas, *Mary Cassatt at the Louvre* (1879–80): probably not one of her most flattering angles but she didn't seem to mind.

1909 In New York Rose Cecil O'Neill designs the Kewpie Doll, an American cupidlike doll, which will earn her $1.5 million.

1917 Austrian pianist Paul Wittgenstein loses his arm while fighting on the Russian front. It doesn't end his career though. After the war, he will commission and perform works for the left hand, written by Strauss, Prokofiev and Britten, among others.

1926 The Hon. Violet Gibson attempts to assassinate Mussolini but the bullet just grazes his nose.

Still, Degas did the Impressionists a good turn by introducing her to them. She was the daughter of a wealthy businessman from Pittsburgh, who had been brought up in France, traveled widely and, despite her parents' many objections, was determined to be an artist. She had lived in Paris, admiring the Impressionists from afar, for over nine years when they met.

> **NAMES IN THE FRAME**
>
> **Cassatt's** *main influence was on a small group of artists whose combination of posters and Impressionism in the next generation became known as Intimisme. Their subject tended to be indoor scenes with a narrative.* **Pierre Bonnard** *and* **Edouard Vuillard** *(see page 122) shared a studio in Paris, and their paintings were instrumental in taking Impressionism into the next century. Check out Vuillard's* Under the Trees *(1894).*

When she encountered Degas, all her submissions to the Salon had just been rejected and he suggested she exhibit with them instead. She did, in four of the Impressionist exhibitions, and her work was very powerful. It was more influenced by Japanese art than any of the others (*see page* 34). Like Morisot's pictures (*see page* 60), it focused on domestic scenes—check out *Feeding the Ducks* (1895) and *In the Omnibus* (1891). But they were much less relaxed, more Post-Impressionist and more puritan than Morisot's. Despite her wealth,

Mary Cassatt, *In the Omnibus* (1891): of all the Impressionists', her paintings most resembled Japanese prints. She was particularly keen on everyday mother and child scenes, which she portrayed in an unsentimental light.

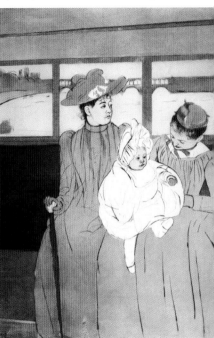

she didn't tend to paint the bourgeois wealthy women that Morisot concentrated on; she was much more interested in ordinary people with ordinary lives.

Like many of the other Impressionists (*see page* 131), Cassatt had trouble with her eyes and she died blind—but not before the Pennsylvania Academy had given her their Gold Medal of Honor.

1878 German immigrant Maximilian Delphintus Berlitz starts his first language school in Rhode Island and develops his easy-to-learn methods, which involve leaving students with instructors who speak no English.

1878 The Tiffany Diamond found in South Africa is the largest ever discovered, at 287.42 carats.

1878 New York gas company shares plummet as Thomas Edison works out a method of cheap production and transmission of electricity for household use.

1878

Sweaty Women
L'Etoile

Edgar Degas, *L'Etoile* (1878): but this time, it isn't a backstage scene, but an unexpected angle.

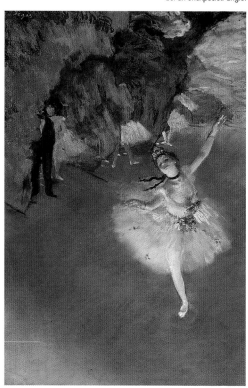

Degas didn't like women much. He hung around the Paris Opéra for decades painting the ballerinas, and women were often the subjects of his paintings, yet he was constantly being accused of the worst kind of misogyny. Were people just assuming he hated them because he painted them warts and all? One critic even claimed that in Degas' paintings women were "soiled by being likened to an animal."

It's true he never married. And it's true that his interest in the ballerinas wasn't because they were pretty girls. He was fascinated by seeing shapes from unexpected angles, and studying light and shade—especially in artificial light. He would say, no doubt, that he was just being objective. Like an Impressionist—except that he claimed he wasn't one of them either. He wasn't much interested in the girls themselves, poor things, just their bodies: this was pornography for the modern artist.

L'Etoile is one of the most famous paintings Degas ever produced, and is all of those things except degrading.

1878 President Hayes invites Washington children to an Easter egg roll on the White House lawn.

1878 Charles T. Russell establishes Jehovah's Witnesses, arguing that the second coming of Christ was in 1874 and that they are all living through a "millennial age" that will end in 1914 with revolution and chaos.

1878 Englishman Eadweard Muybridge publishes his famous multiple exposure photographs of animals and people in motion.

The prima ballerina is a kind of angel pirouetting in the footlights. She may have only one leg, and one arm is clearly shorter than the other, but you can see the swirling movement and her delight in it.

Offstage, and revealing themselves rather menacingly, are the legs of one of the powerful "lions"—the rich men who hung around behind the scenes at the Paris Opéra hoping to have affairs with the dancers. The truth is that Degas was a good deal more interested in what went on backstage than what was happening out front. There are far more pastels of the dancers at rehearsal or in the dressing rooms—check out, for example, *Awaiting the Cue* (1879)—than there are of them performing.

L'Etoile doesn't look like a photograph—it's executed in pastel—but the composition is similar to many of Degas' pictures. You don't see whole people in this or *The Curtain* (1880)—another pastel of a performance with "lions" very much in evidence. The girl is caught in a moment of flight. Caillebotte liked it so much he bought it for his collection (*see page* 34).

Miss La La

In 1879 Degas stole the show at the fourth Impressionist exhibition with his picture of the acrobat Miss La La being pulled up to the roof of the circus by her teeth. Unlike his other pastels, *Miss La La at the Cirque Fernando* is a finished painting and the result of four chalk sketches that he took home and translated on to canvas. It was very un-Impressionist behavior.

Edgar Degas, *Miss La La at the Cirque Fernando* (1879): another rather unusual, upside-down view, almost looking up the acrobat's skirt.

NAMES IN THE FRAME

Another of Degas' most famous dancing pictures, The Dance Class *(c. 1873-6), is also very far from being a quick impression sketched in oils on the spot. In fact, it's a finished painting which took him years to complete. Critics have always commented on the fact that the dancers don't seem to be paying attention to the famous choreographer Jules Perrot. The reason is that he was probably painted in later.*

1879 About 90 passengers are killed when the Tay Bridge collapses while the Edinburgh to Dundee train is crossing it.

1879 Saccharine is discovered accidentally at a laboratory in Baltimore; it is 300 times sweeter than sugar and good news for diabetics.

1879 The last member of the southern bison herd is killed by buffalo hunters in Texas.

1879~1880

Wonky Tables
Still-Life with Compotier

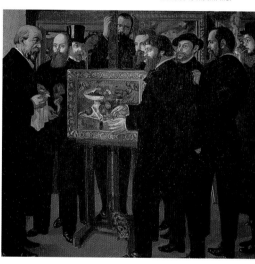

Maurice Denis, *Hommage à Cézanne* (1900): a tribute not just to the man himself but also to his still-life.

If someone painted a still-life in which it looks as if the table is sloping forward and the apples about to roll off on to your lap, you wouldn't think they came from an artistic school that was influenced by impressions and photography. But then Paul CÉZANNE (1839–1906) was different from the others; he was holed up in Aix-en-Provence and thinking beyond Impressionism to the far-off shores of the future of art.

Actually he painted over 200 still-lifes, and most had apples in them. Even thinking of painting a subject like that was a revolutionary act, because still-lifes had attracted serious disapproval from the conservatives in the Salon. They didn't think they had any moral content. The Impressionists didn't worry about that— they didn't see it as their job to deliver moral messages—but they tended to avoid still-lifes because they weren't so easy to paint out of doors.

NAMES IN THE FRAME

Still Life with Compotier *was actually owned by Gauguin (see page 100). It was also used by one of Cézanne's greatest admirers, the symbolist artist* **Maurice Denis** *(1870–1943) in his painting* Hommage à Cézanne *(1900), which managed to be a tribute to the great man himself as well as to the Renaissance artists that Denis revered. It's mighty strange the way that art just keeps coming around full circle.*

1879 France's prince imperial is killed by a Zulu spear when he accompanies the British army in Zululand.

1879 James Ritty invents a cash register that records transactions on a paper roll, to try and stop his bartenders pilfering the takings from his saloon in Dayton, Ohio.

1880 Dostoyevsky writes *The Brothers Karamazov* the year before he dies.

So Cézanne plugged away alone. He was much more interested in shapes and colors and their relationship to each other than he was in fleeting impressions. So why not just tilt the table a little so we can see what's going on there?

In *Still-Life with Compotier* (1879–80) everything is in pairs, and the pairs are complicated by having pairs of colors too. It was as if Cézanne was trying to reinvent art afresh from the very beginning. If perspective wasn't useful to him, he chucked the whole idea out—just as the Salon rejected him in 1880. It was a lonely and miserable business.

Some of the still-lifes he painted in this period have a strange star pattern in the background on what looks like a yellow background, which historians believe was the wallpaper in his Paris flat at 67 rue de l'Ouest: check out, for example, *Compotier and Plate of Biscuits* (c. 1877). And it was around this time that he started painting his trademark apples.

The critics came to love the apples. Even curmudgeonly Degas bought some. And the novelist and critic *Joris-Karl Huysmans* (1848–1907) said that they "initiate us into mysteries," describing them as: "Apples that are brutal, rugged, built up with a trowel, abruptly subdued with the thumb." It just took a bit of mild concentration on a simple fruit and suddenly still-life was at last accorded the respect of art historians.

Fruity

The other Impressionist painter who tried his hand at still-life was Renoir, but typically, he saw these things rather differently. His still-lifes are sumptuous, brightly colored affairs, containing not only ordinary fruits like apples, but also sweet exotic vegetables. Have a look at *Fruits from the Midi* (1881) and you'll see what I mean.

Paul Cézanne, *Still Life with Fruit Bowl and Plate with Biscuits* (1879–80). Notice the pairing of objects and colors in the composition, his "apple" period.

1880 Work begins on a Channel Tunnel at Folkestone in Kent but stops again after only 2,884ft (879m).

1880 Offenbach dies a year before his *Tales of Hoffmann* premieres in Paris; his Barbarelle aria is a particular success.

1881 President Garfield is shot and killed in a Washington DC train station by someone to whom he had refused a job.

1880~1881

Bleary Picnic
Luncheon of the Boating Party

"Alas, I am a painter of figures," said Renoir sadly, when he heard about the amazing progress Monet was making experimenting with landscapes. It was Renoir's tragedy but also his genius. The point was that—from a gawky youth to a revered artist, half-paralyzed in a wheelchair—Renoir was fascinated by exactly the same thing: round-faced, buxom, joyful women. He just loved them. If Zola wanted artists to paint more of modern life, then as far as Renoir was concerned, this was what it consisted of.

La Loge
Renoir's *La Loge* (1874) was another painting able to give the impression of tiny movements—in this case little more than fluttering eyelids. It was the only picture in the first Impressionist exhibition to escape the general mauling by the critics.

Perhaps that's a little unfair. He was also interested in being like a kind of camera that captured a moment in time, with all the passing expressions and blurred activity. Either way, *Luncheon of the Boating Party* (1880–1) has become one of Renoir's most famous paintings. The public liked it right from the start.

They first saw it at the seventh Impressionist exhibition in 1882—the one organized by Durand-Ruel (*see page 66*)—while Renoir was away recovering from pneumonia. He might have chosen different pictures if he'd been there himself, and might thus have avoided one of the few criticisms of it from the critic Huysmann (*see page 89*): "They do not exude the aroma of Parisians," he

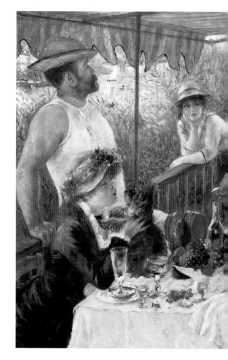

1881 There is a severe storm in Worcester, England, with hailstones and periwinkles falling from the sky.

1881 In California, James Harvey Logan creates the loganberry by crossing a red raspberry with a wild blackberry.

1881 Swiss author Johann Spyri writes the sad tale of *Heidi*, a little girl who has to leave her grandfather in the mountains to go to school in the valley.

complained about Renoir's partying women. "They are springlike trollops fresh off the boat from London."

Actually, they weren't. The girl in the far left, enjoying the company of her dog on the table, was *Aline CHARIGOT* (1861–1916), whom Renoir later married. The others were frequent visitors to the Restaurant Fournaise by the Seine, which Renoir used as a setting. Check out his portrait of the owner *M. Fournaise* (1875) with his cap and pipe. As usual, Renoir had included his friends.

There's a blurred quality about the painting. It may be partly the effects of looking at so many half-empty bottles of red wine, but it's also Renoir's attempt to capture movement like a lens. He went even further the same year with his extremely blurred painting *The Place Clichy* (c. 1880), of a bustling street scene with a great big space in the corner of the canvas which is waiting for the girl to walk into it. That was the thing about photography in those days. The shutter speeds were so slow that, unless everybody stayed stock still, any figures in the picture were likely to be pretty blurred.

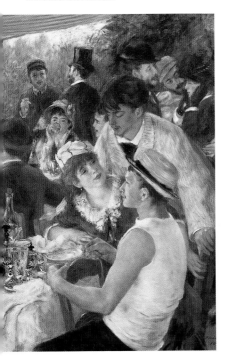

Pierre-Auguste Renoir, *Luncheon of the Boating Party* (1880–1): an attempt to capture a split second in time, showing Parisians enjoying themselves under sunny skies at the riverside Restaurant Fournaise.

NAMES IN THE FRAME

While Renoir was experimenting with painting photography-like effects, the Anglo-American pioneer **Eadweard Muybridge** *(1830–1904) was publishing his book of photos* The Horse in Motion *(1878)—which showed for the first time what a horse did with its legs at high speed if you freeze-framed the pictures. Degas was among those fascinated by the book. In the year when Renoir was painting his* Luncheon, *Muybridge was busy inventing his zoopraxiscope, the forerunner of the moving pictures, which shot light on a disk of photos giving the impression of movement.*

1880 Half of New York's population is housed in tenements on the Lower East Side, an area that accounts for 70 percent of the annual deaths in the city.

1883 In Britain, the Corrupt and Illegal Practices Act limits spending by political parties in general elections.

1886 The first Crufts dog show is held in Britain. Fifi and Rover are expected to be on best behavior.

1880~1900

Join the Dots
Seurat and pointillism

The point about Seurat's pictures is that they have to be seen from exactly the right distance away. Too close and all the little dots separate; too far away and you don't get the full effect of the composition. It's that kind of thing that irritated the Impressionists about him. How could an artist be so like them and yet so extremely different? And just when they were beginning to get some public recognition too.

Clear as mud
This is how Seurat explained his theories in 1890: "Harmony is the affinity between contrasts, the affinity between similar things, tones, colors, lines." The inclusion of the words "things" and "lines" were proof positive that a new era was beginning. The Impressionists hadn't been much interested in either.

Georges SEURAT (1859–91) was one of those revolutionary thinkers who believe themselves to be chosen by history, work incredibly hard and die young. Like some of the Impressionists, he went to the École des Beaux-Arts, was influenced by Chevreul's color theories (*see page 22*), and came to believe it was the artist's role to paint modern life as it really was. But that was as far as it went.

He aimed to turn Impressionist individualism into a precise scientific discipline, using lots of tiny colored dots. They were all the pure primary colors of the spectrum, and only ever mixed with white. Like the Impressionists, Seurat and his "pointillists" banned black from the palette. They also forced figures into the harmonious lines that Seurat had mapped out. No more Impressionist spontaneity or finishing out doors. But the result was supposed to be brighter and monumental.

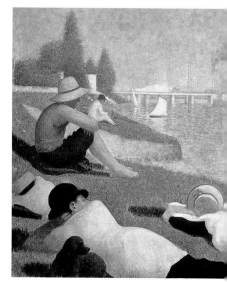

Georges Seurat, *Bathers at Asnières* (1883): a new school was emerging.

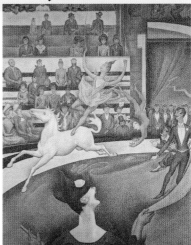

Georges Seurat, *The Circus* (1891): stylized and not really Impressionism–all very confusing.

It was also much more stylized and, by the end, pointillism, divisionism, Neo-Impressionism—call it what you like—was verging on the abstract, with strange, thin, idealized figures dancing, playing instruments or waggling the ends of their cellos.

Seurat didn't have a long career before his early death at the age of 32, but he still managed to fit in three phases of work. First, his sketches of people bathing by the Seine turned into the two enormous pictures that made him famous: *Bathers at Asnières* (1883) and *Sunday Afternoon at the Island of La Grande Jatte* (see page

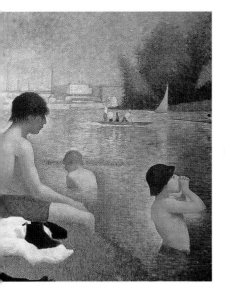

110). From 1885, there were his seascapes. And from 1888, he followed Degas into popular entertainment, with works that were more like posters than paintings. The inclusion of Seurat and his friend Signac in the eighth Impressionist exhibition in 1886—even if they were confined to a separate room—split the movement. It was clear that there were alternative answers to the questions the Impressionists had raised.

NAMES IN THE FRAME

Seurat's friend **Paul Signac** *(1863–1935) was his most energetic proponent. Together they formed the Salon des Indépendants, and after Seurat's death he meandered down to St-Tropez to mix with the artists of the future, like Matisse (see page 123). Check out his* Cherbourg, Forte de Roule *(1932).*

1881 *Atlantic Monthly* publishes an attack on John D. Rockefeller's Standard Oil Co. in an article entitled "The Story of a Great Monopoly".

1881 The vaporetto is introduced in Venice and gondolas quickly become a conveyance used mainly by tourists.

1881 There is a shootout at the OK corral just outside Tombstone, Arizona, between Wyatt Earp and his brothers alongside the alcoholic Doc Holliday against Ike Canton, Billy Claiborne, and their gang. The Earps win.

1881~1882

Come Back Raphael, All is Forgiven
Renoir goes to Italy

In the early 1880s, Renoir experienced something of a thunderbolt. He went to Italy to escape what he called his "sour" period, and rediscovered Classical art. When he came back, he wanted none of this instantaneous stuff and these fuzzy outlines; he wanted art that could be as permanent and Classical as Raphael or Michelangelo.

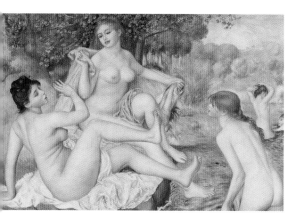

Pierre-Auguste Renoir, *Les Grandes Baigneuses* (c. 1887): sharp outlines and posed bodies. He liked his nudes to be voluptuous and portrayed them using sensual colors.

traditional Romantic subjects and Classical composition. "I have come to the end of Impressionism," he wrote.

Renoir only visited Italy for three months in 1881, accompanied by his new mistress Aline Charigot (*see page* 90). But when he came back, the paintings of Raphael and the frescos at

"At my age, I do not want to be a revolutionary," he wrote in an unsent letter to Durand-Ruel (*see page* 66), explaining why he didn't want to take part in the 1884 Impressionist exhibition. He was only in his early 40s, but a wave of conservatism had overtaken Renoir. He knew what his wealthy patrons wanted, but he could also see that Seurat's impact was creating a new revolution in art; the future seemed to lie in a return to

NAMES IN THE FRAME

By the end of his life, Renoir was choosing all his servants not by whether they could do the work, but according to whether their skin "took the light." Hence the nurse Gabrielle in so many paintings at the time—see Gabrielle Reading *(1890).*

1882 Italy takes over the northern Ethiopian town of Assab.

1882 An electric two-bladed desk fan is invented in New York by an employee at the Electric Motor Co.

1882 Lillie Langtry makes her US debut in a play called *An Unequal Match*. She is commonly known as the "Jersey Lillie" after the title of painting of her by Sir John Everett Millais.

Pompeii had made their mark. He started experimenting with Classical myths, Classical titles and sharp outlines, brought to an extreme in *Les Grandes Baigneuses* (*c.* 1887). This time he copied the Renaissance masters by doing lots of preliminary sketches. Even the leaves changed from blurred impressions to what one critic referred to as "cough lozenges."

Renoir later went back to the fuzzy Impressionist outlines, but he never quite gave up the Classical drapes: check out *La Boulangère* (1904). And he stuck to nudes through thick and thin—or in Renoir's case decidedly plump, with wide smiling faces and identically sized breasts. See, for example, *La Toilette* (1902) or *Gabrielle with an Open Blouse* (1907).

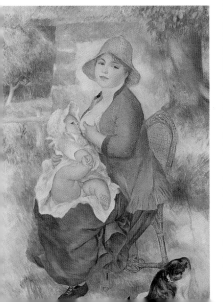

Grand tour

Renoir's first stop on the Italian trip was Venice; he was bowled over by the city and painted whatever he saw—like *St. Mark's Square, Venice* (1881), shown above. He confessed his big Impressionist sin to Durand-Ruel: he didn't finish them in the open air but took them back to his studio in Paris and finished them there. Compare them with Manet's views of Venice (*see page 40*) and Whistler's (*see page 85*). However revolutionary the first Impressionists were, many of them popped up in Venice sooner or later.

He saw this work as rooted in a clear artistic tradition, like his *Maternité* (1885). "They are a continuation of the 18th century," he told Durand-Ruel, sending his latest consignment, but "not as good."

Until the end of his life, even when he was crippled by arthritis after 1912, Renoir pursued the same ideal of beauty, with ever-more escapist pictures of women. There's no doubt where his tastes lay.

Pierre-Auguste Renoir, *Maternité* (1885). His techniques changed, but his tastes remained the same—fleshy women with large breasts.

1881 Billy the Kid escapes from jail but is shot dead in New Mexico. Within weeks, *The True Life of Billy the Kid* is a bestseller in New York.

1881 The population of the US is 53 million; Britain has 29.7 million; Germany 45.2; France 37.6, and Italy 28.4.

1881 Cuban doctor Carlos Juan Finlay suggests that mosquitoes carry yellow fever.

1881~1882
Urban Chic
Bar at the Folies-Bergère

The artist provokes his subject.

What can Manet possibly have said to the poor barmaid in his last masterpiece Bar at the Folies-Bergère *(1881–2) to make her look quite so thoughtful and poignant? Whatever it was, she seems for some reason to be refusing to look either the artist or us in the eye. As with Leonardo Da Vinci's* Mona Lisa *this is one of arts great mysteries.*

Manet's last masterpiece saw him emerging from his truly Impressionist period and going back to his old calling—painting modern life as it really was. And modern life was never as intense as it was in the Folies-Bergère, one of the most famous cafés in Paris and the venue for the city's best-known café concerts.

It's a bit of a sad painting too. It was accepted by the Salon in 1882, giving Manet the recognition by the artistic establishment he had always longed for, but the following year he suffered from paralysis in his leg, then gangrene, and died. The picture is also a homage to his friend Zola, inspired by a passage in Zola's novel *Le Ventre de Paris* (1873) which Manet owned an autographed copy of. (This was before the publication of Zola's controversial *l'Oeuvre; see page 70* for that story.)

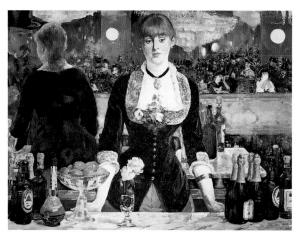

Edouard Manet, *Bar at the Folies-Bergère* (1881–2). Manet and Degas were regulars there throughout the 1880s. Shouldn't it be the artist reflected in the mirror? Or us, the viewers?

1882 *New York Sun* city editor John Bogart famously explains "When a dog bites a man, that is not news; when a man bites a dog, that is news."

1882 Jumbo the Elephant appears at the Madison Square Garden. He stands 11ft 6in (3.5m) tall to the shoulders and weighs 6.5 tons.

1882 Italian author Carlo Collodi writes about the adventures of Pinocchio, a wooden puppet whose nose gets longer every time he tells a lie.

For sale

In 1884, the year after Manet's death, Durand-Ruel organized a sale of works of art in his studio. But three of the most important pictures were withdrawn without a bid because Durand-Ruel has priced them too high. Caillebotte bought *The Balcony* (*see page 60*) for 3000 francs and the auction fetched a staggering 116,637 francs in total. It was the start of a period of near bankruptcy for Durand-Ruel. Many of his Impressionist clients suggested that he lower the prices.

There's also rather a mystery in it. We know the woman was called Suzon and she really was a barmaid at the Folies-Bergère, but the person who should be in our place—the viewer looking in the mirror—isn't us: it's a portrait of an artist friend of Manet's called Gaston Latouch. The viewer has disappeared completely: and that's a kind of Impressionist ideal in itself; the viewer of the scene is so objective that they might as well not be there at all.

But Manet was backing away from many of the tenets of Impressionism by now. The picture wasn't painted on the spot: it was done in his studio, where Suzon very kindly came and posed for him. But if you look in the mirror behind her, there lies modern life in 1880s Paris, ranged in front of us with all its top hats and temptation, just as it really was.

Manet died at the age of just over 50, the reluctant leader of the Impressionist movement. What would he have painted if he had lived to see the new influences in art at the turn of the century?

Edgar Degas, *The Café Concert at the Ambassadeurs* (1876–7): one of Degas' favorite haunts, providing just the slice of modern life he reveled in. The drama and interactions are captured as if at a split second in time.

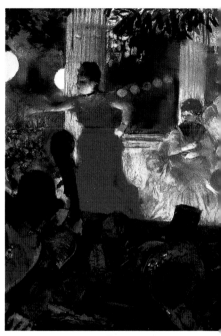

Café life

Manet and Degas were by far the most interested in café life of any of the Impressionists. They painted pictures that aren't really supposed to tell a story—just show life as it was lived at the time. Check out, for example, Manet's *The Reader* (c. 1878–9) and Degas' *Café Concert at the Ambassadeurs* (1876–7). Neither of them really appreciated their colleagues' fascination with landscape or painting out doors.

1883 The eruption of Krakatoa in Indonesia causes spectacular red sunsets all around the world.

1884 Quaker Oats are one of the first foods to be sold in cardboard packages and there is a massive advertising campaign throughout Britain and the US.

1885 Amsterdam's Rijksmuseum, which was founded by Louis Bonaparte in 1808, moves into a grand new building.

1883~1890
Camille Goes Dotty
Pissarro's Neo-Impressionist phase

Georges Seurat, *The Eiffel Tower* (1889): the world's first pointillist was just getting into his stride with this image.

Pissarro was probably the most faithful to the principles of Impressionism throughout his life, just as he was most faithful to his Impressionist friends. He didn't squabble and he stuck to the matter in hand: he just carried on painting his impressions of the moment, if possible out of doors. But around 1883, something happened to upset all that.

"I am much disturbed by my unpolished and rough execution," he told his son Lucien that year. Just as Renoir and the others were having doubts about the whole Impressionist idea, Pissarro was wondering whether he ought somehow to make his paintings smoother. And to this end, he embraced the ideas of Lucien's friends the pointillists (*see page 92*).

Window on the world
The moment Pissarro went back to painting out of doors, he found his eyes began to fail and he had to go indoors again. From then on, his habit was to paint scenes from behind closed windows. He was about to enter the greatest decade of his life. Although he was never what you would call a brilliant success, his bustling street scenes and pictures of Rouen and Paris are some of the most successful he ever painted. Check out, for example, his *Place du Théâtre Français* (1898).

It was Pissarro who persuaded the others to include Seurat and Signac in the 1884 exhibition—and practically destroyed the unity of the group by doing so. Soon he was adopting Seurat's new "scientific" technique, using dots of primary colors to create a special intensity of brightness.

1886 Johnson's wax is introduced by a parquet flooring merchant in Wisconsin.

1886 Alan Breck is rescued from a sinking ship in Robert Louis Stevenson's *Kidnapped*, published this year.

1888 American shopkeeper William Burroughs patents an adding machine that gives the right answer every time but it is not yet commercially viable.

Camille Pissarro, *Ile Lacroix, Rouen—Effect of Fog* (1888): Pissarro's controversial leap into Neo-Impressionism. Over the years, his colors became lighter and his brushwork looser.

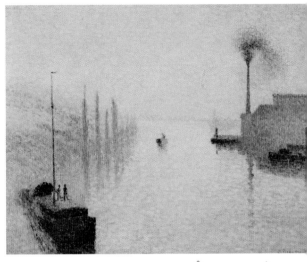

The result was one of his most famous paintings ever. *Ile Lacroix, Rouen—Effect of Fog* (1888), one of the classic pictures of smog. There isn't much distinction between the sky and the water, and both seem to quiver with a great impression of space. Two lonely figures on a barge in the foreground appear to be blowing mist out of their mouths.

At the final Impressionist exhibition in 1886, visitors found it hard to tell the difference between Seurat's, Signac's and Pissarro's pictures. The transformation was complete. It just didn't last. Pissarro began to feel the whole idea of dots was getting in the way of his spontaneous response to scenes. "Having found after many attempts that it was impossible to be true to my sensations and consequently to surrender life and movement, impossible to be faithful of the effects, so random and so admirable, of nature, impossible to give an individual character to my drawing, I had to give it up," he said, being rather long-winded about it.

Seurat's pointillism wasn't supposed to be individual—it was supposed to be scientific—so if Pissarro thought like that, it wasn't surprising he gave it all up. There were other reasons too: his friend Gauguin (*see page* 100) had turned against him when he started dabbling with dots, and his long-suffering wife became so desperate about his new unpopularity and his redoubled debts that she nearly drowned herself.

TECHNIQUES

Seurat's pointillist technique involved laying down a layer of fine light paint and then painting dots of pure color next to each other—for example, yellows next to blues for the grass—so that they are mixed optically rather than on the palette. See Pissarro's version of the technique in *Woman in a Field* (1887).

1886 Robert Louis Stevenson writes *The Strange Case of Dr. Jekyll and Mr. Hyde* in three days and three nights.

1888 British inventor John Boyd Dunlop develops a pneumatic tire with a rubber casing and an air-filled inner tube that can be inflated using a pump.

1891 A New Orleans lynch mob bursts into a jail and kills 11 Italian immigrants who have been acquitted of murder. It is the worst lynching in US history.

1883~1903

Going Native
Gauguin and Synthetism

Gauguin's poor wife claimed that when they married, she had no idea he painted pictures. As far as she was concerned when she walked down the aisle, she was marrying a successful former sailor turned stockbroker—who maybe tinkered with buying the occasional Impressionist painting in his free time. Little did she know, she had just taken vows of eternal fidelity to the pioneer of primitive art.

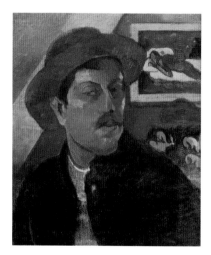

Paul Gauguin, *Portrait of the Artist* (1892–4): ten years after his escape from the old stockbroking life. At this point he had already traveled through Latin America and lived in Tahiti for two years.

It was the start of a series of lonely, heartbreaking, increasingly poverty-stricken wanderings that would divide him from his family and friends. There were visits to South America, a disastrous holiday with Van Gogh (*see page 114*), and a long stay in Pont-Aven, Brittany, where the idea of Synthetism or Symbolism began to come together in a whole new school. Soon he and his Synthetist colleagues were trying to paint emotions and moods with slabs

Paul GAUGUIN (1848–1903) was brought up in Peru—so it may be that he got that fatal taste of the South Seas from an early age. He met Pissarro in Paris and a slow-burning fuse was lit. He took part in the Impressionist exhibitions and, at the age of 35, he gave up stockbroking altogether to devote his life to painting.

A piece of advice

"One piece of advice," wrote Gauguin. "Don't paint too much from nature. Art is an abstraction, draw it from nature by dreaming before nature. Think more of the creation that will result. The only way to rise toward God is to do as our divine master does—create." For Gauguin, the Impressionist idea of simply reproducing a moment or a scene was not nearly enough.

1895 Henry Irving receives the first knighthood to be awarded to an actor.

1899 The Boer War begins in South Africa as President Kruger acts to stop Britain seizing the gold mines of the Transvaal.

1903 Britain creates a National Art Collections Fund to try and prevent works of art from leaving the country.

of bright color, separated by black lines. It borrowed from Japanese prints and primitive art, but it was all a long way from Impressionism.

Gauguin had a dramatic effect on Pont-Aven, and soon a growing school of younger artists was gathering there to learn; they held a joint exhibition during the Paris Exhibition in 1889 (*see page 100*). Synthetism was a strange mixture of Celtic ornamental styles—which would eventually be transformed into Art Nouveau (*see page 124*)—together with medieval religious symbols and Gauguin's increasing fascination with primitive art.

"There are two natures in me: a sensitive one and a savage," he told his wife. "The sensitive one has disappeared, which allows the savage to walk straight and firmly." In 1891 he set out for Tahiti to "be rid of the influence of civilization," and he devoted the rest of his life to painting exotic naked women on beaches, pink skies and red dogs.

Sadly, Gauguin's final years were spent in crushing poverty and ill-health,

> ### NAMES IN THE FRAME
> *Gauguin's work had two major influences. One was the precocious poet **Arthur Rimbaud** (1854–91), who achieved immortality for the handful of poems that he wrote between the ages of 10 and 20— and for his praise of our primitive nature. He then gave up poetry to become a trader. The other was the religious imagery of **Émile Bernard** (1868–1941), who developed the strong flat color technique with Gauguin when they met in Brittany. They quarreled later because Gauguin took all the credit for it.*

combined with battles with the colonial authorities over his various native causes. He died at Atuana at the age of only 55.

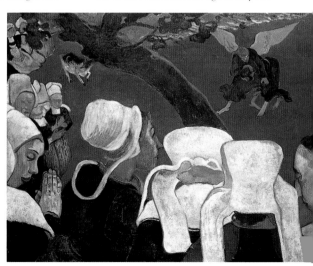

Paul Gauguin, *The Vision After the Sermon* (1888). The only "impressionist" painting of Jacob wrestling an archangel.

1884 Maupassant writes "The Necklace", examining hypocrisy in Parisian society.

1893 Czech composer Dvorak's *New World Symphony* is inspired by Negro spirituals and Native American music.

1898 Pierre and Marie Curie discover two new elements—radium and polonium.

1884~1917

Bits of Body
Rodin

Pierre-Auguste Renoir's drawing of Rodin (1915).

When the first major work by the great sculptor Auguste RODIN (1840–1917) went on show in the 1870s, it was so accurate and lifelike that a rumor went around that he had taken a cast from a live model. It was the public's way of dismissing the man who would become the most famous artist in France.

In fact, nobody took much notice of the work that made his name. *The Bronze Age* (1877), until it was shown in London in 1884, and then—just like the Impressionists—they weren't at all sure whether they liked it or not.

Rodin was born in the same year as Monet, the son of a police official. He began his career as a freelance stonemason working on decorative figures for the new

Auguste Rodin, *The Bronze Age* (1877). This beautiful sculture of a young boy made him exceptionally famous.

Stock Exchange in Brussels. You won't find him in any of the standard works about Impressionism. but although he was much more famous and successful in his lifetime than they were, he does in some ways belong in the same category. It was his joint exhibition with Monet during the Universal Exhibition of 1889—the show that gave the world the Eiffel Tower (*see page 30*)—that finally made Monet a financial success.

The point is that, despite his enthusiasm for Michelangelo, Rodin didn't really believe his works should be completely

TECHNIQUES

It was a long process making a bronze statue, even after the sculptor had finished. First the bronze caster had to produce a mold, from which working models would be made in bronze, and then the final casts would be taken from these. The Italian Albino Palazzolo was awarded the Legion of Honor in 1921 for all the work he did casting the statues carved by Rodin and Degas.

1904 Ice cream cones are sold at the St. Louis Fair. A Syrian pastry chef rolls his wafers into cone shapes after the neighboring ice cream stand runs out of dishes.

1911 The Manchu dynasty ends when the boy emperor P'u-I abdicates and a republic is declared in China.

1917 Picasso meets Russian ballerina Olga Khokhlova at the Paris première of the ballet *Parade* and follows her company to Spain. They marry the following year.

finished. Something should be left to the imagination. Sometimes he left part of the unworked stone in place to show his figures emerging—or bits of figures: he specialized in hands or studies of individual parts of the anatomy. This technique exposed him to public rage because people thought he was being lazy. They presumed he couldn't be bothered to finish the rest of the body.

Conventional artistic opinion held that works of art should take ages and look completely finished. Rodin always contrived to leave enough rough stone to give his works a spark of life.

The great thing about being a sculptor is that there can be more than one original of each work—because they may all be taken from the original cast. There are more than 150 originals of *The Bronze Age* alone. But it does mean that you can see Rodin's work more easily: the best collections are in the Musée Rodin in Paris and the Rodin Museum, Philadelphia.

NAMES IN THE FRAME

Rodin *was one of the unluckiest public sculptors ever. His* Thinker *was attacked by a vandal. His* Burghers of Calais *(1884–6) was messed with by Calais's town council. His* Hugo *and* Balzac *monuments were meddled with by commissioning committees for years, and his* General Lynch*—the only equestrian statue he ever made—was destroyed by a mob in Santiago during the Chilean revolution.*

Unfinished

The term used to describe Rodin's technique is the Italian *nonfinito*, meaning "unfinished." In his case, it meant that he would model only a torso or a hand rather than the whole caboodle. His ideas were often executed by his studio assistants, and it was common for other sculptors to carve parts of his work and cast from his designs.

Auguste Rodin's *Thinker* (c. 1880): it has passed into the visual language of modern culture.

1885 Gilbert and Sullivan's *The Mikado* is a massive success in London with songs including "I've Got a Little List" and "Three Little Maids from School."

1891 Gold is discovered at Cripple Creek in Colorado and by the end of the decade, the town has a population of 60,000 served by 139 saloons that are open around the clock.

1900 The almost child prodigy Pablo Picasso paints *Moulin de la Galette* at the age of nineteen.

1884~1937

Colorful Notes
Impressionist music

When Claude DEBUSSY (1862–1918) was admitted to the Paris Conservatoire at the frighteningly early age of ten, the professors immediately realized that they had somebody unique on their hands. Although he loved music and was clearly going to be a brilliant pianist, he seemed to dislike the instrument itself. By adulthood, he had swapped over to composition classes, without much effect: he seemed to dislike many of the conventions about writing music, too.

It was the start of what contemporaries referred to as Impressionist music, trying to capture in sound the same fleeting emotions that the Impressionists were trying to capture in a painting. Debussy used layers of notes like layers of color, and dissonances between notes that might have a parallel in Chevreul's theories about the simultaneous contrast of colors (*see* page 22). Critics talked about his sounds in terms of color too.

His parents ran a china shop in St. Germain-en-Laye and couldn't understand their son. But despite their lack of support, Debussy won the prestigious Prix de Rome in 1884 with his cantata *The Prodigal Son*. He had a

The cover of Debussy's *La Mer*, (1904), using the famous Hokusai print of a wave breaking.

Nijinsky dancing Debussy's *Prélude à l'après-midi d'un faun*, which was inspired by the Symbolist poetry of Mallarmé.

1903 The Prix Goncourt, France's top literary prize, is awarded for the first time from a fund donated by novelist Edmond de Goncourt.

1922 Oxford bags are in fashion with everyone competing to see who's got the widest trouser legs.

1937 In Britain, the telephone service known as the speaking clock is introduced.

Water works

Just as Monet was struggling away trying to depict water and waterlilies (*see page 128*), and pushing Impressionist technique to its furthest extreme in order to do so, Debussy was also struggling with the method of portraying water in music. He came up with long strings of inter-linked dissonances, which just flow along. You can hear them in his piece *Reflections in the Water*.

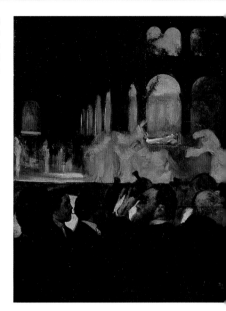

Edgar Degas, *The Ballet Robert de Diable* (1871–2): Degas also included music in his repertoire.

disastrously complex and overwrought love life—full of betrayed fiancées and threatened suicides—but he was gaining increasing recognition for his work. Soon he was setting poems by some of the Impressionist poets to music: his *Prélude à l'après-midi d'un faun* (1894) was inspired by the Symbolist poet Stéphane Mallarmé (*see page 71*).

The reaction of mainstream critics was very similar to the original reaction to Impressionist paintings ten years earlier: they considered him to be either careless or downright perverse.

While on the run with a new mistress to escape the previous one in 1904, Debussy took refuge in the Grand Hotel, Eastbourne, where he finished his three famous orchestral sketches known as *La Mer*. On the cover of the printed version, he used a picture by the Japanese artist Hokusai (*see page 35*), because—you've guessed it—Debussy was also a great admirer of Japanese prints. He was also enormously influenced by *Frédéric Chopin* (1810–49) and by the gamelan players at the 1889 Universal Exhibition in Paris.

NAMES IN THE FRAME

Debussy has been hailed as the father of modern music, and among his Impressionist followers were the dreamy English composer **Frederick Delius** *(1862–1934); his French colleague* **Maurice Ravel** *(1875–1937) who—like Debussy—ended up working on ballet scores for the fearsome Russian impresario* **Sergei Diaghilev** *(1872–1929); and the depressive French composer* **Emmanuel Chabrier** *(1841–94). But Debussy didn't so much create a school as show that many of the conventional rules of composition could be changed.*

1885 Britain's first cremation in modern times takes place at a crematorium in Woking, England.

1889 The Socialist song "The Red Flag" is written in London following a dock strike.

1892 British chemists Charles Cross, Edward Bevan and Clayton Beale produce viscose which makes the manufacture of rayon possible.

1885~1914

Mad, Bad, and Dangerous to Know
Post-Impressionism

By the mid-1880s, Impressionism was in a bit of a crisis. Monet had argued with almost everybody. Renoir was trying to become a Classical artist. Pissarro was trying to become a pointillist. Cézanne was in exile down in Aix. Degas had infuriated the rest and was declaiming louder than ever that he had never been an Impressionist. The movement seemed to have reached, if not the end, at least a major crossroads.

But it was at this point that the new giants of modern art began to emerge. They had learned the lessons of Impressionism and wanted to move on. Many of them had started out as Impressionists, but they had seen the limits of what Impressionism could do and they weren't any more satisfied with it than the Impressionists were. It was as if it was brilliant but still untidy, they said. It was too fleeting to be able to tackle the depths of nature and human life. It was all light and shadow, so it couldn't be passionate or intense enough to speak to the world.

Three artists in particular would dominate the next generation of art—as

Café Volpini

There was another crucial moment in the development of Post-Impressionism in the summer of 1889, when Gauguin and his followers held their famous Impressionist and Synthetist exhibition at the Café Volpini in Paris, showing paintings that had been turned down by the Universal Exhibition, which was going on at the same time across town.

Cézanne's studio as it is today, just as he left it, in Aix-en-Provence. It was preserved when he became an accepted elder statesman of the art world.

shocking in their way as their Impressionist predecessors. They went in their own directions and started their own trends, but they had a number of things in common. Cézanne (*see page 50*), Van Gogh (*see*

1898 César Ritz, founder of the Paris Ritz, suggests to London liqueur-maker Marnier La Postolle that he calls his orange-flavored liqueur Grand Marnier.

1903 Enrico Caruso makes his American debut at the Metropolitan Opera House singing Verdi's *Rigoletto*.

1911 Edith Wharton writes *Ethan Frome*, a tragic love story set in New England.

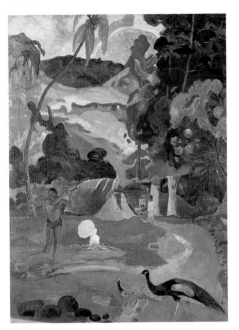

and the dealers—didn't understand them. Even so, the future was with them. This is how the art historian Sir Ernst Gombrich put it: "What we call modern art grew out of these feelings of dissatisfaction... Cézanne's solution ultimately led to Cubism, which originated in France; Van Gogh's to Expressionism, which found its main response in Germany; and Gauguin's to the various forms of Primitivism."

The Impressionist movement, in other words, was beginning to fragment. They hadn't been the avant-garde for very long.

Paul Gauguin, *Landscape with Peacocks*, or *Matamoe* (1892): Gauguin was fascinated by the simplicity of the primitive world and disrupted his family life in pursuit of the real thing.

page 114) and Gauguin (*see page* 100) knew each other. They all took their inspiration not from the streets of Paris, but from the color and light of the south of France. They were also all driven, intense and mildly unstable characters.

If the Impressionists suffered because they were poor, the Post-Impressionist masters suffered because of their characters: Cézanne alone and compulsive down in Aix, Van Gogh catapulted toward illness and suicide, Gauguin escaped into exile in the South Seas. They were troubled people, and the Impressionists—who didn't really have troubles beyond their critics

NAMES IN THE FRAME

There was a crucial moment in the development of Post-Impressionism when the young painter **Paul Sérusier** *(1863–1927)—later one of the founders of the Nabis (meaning "prophets") group— met Gauguin in Brittany in 1888 and watched him paint* The Talisman *on the back of a box of cigars. "How do you see this tree?" asked Gauguin as he painted. "It's green isn't it? Use green then, the greenest of your palette. And this shadow, isn't it blue? Don't be afraid to paint it as blue as possible."*

1885 Germany annexes Tanganyika and the island of Zanzibar in Africa.

1892 Oscar Wilde falls in love with Lord Alfred Douglas; three years later he will go to jail because of it.

1904 British engineers Charles Rolls and Henry Royce form a car manufacturing company in Liverpool.

1885~1942

Indoor Impressionists
Sickert and the Camden Town Group

Fine: paint impressions if you must, use all the techniques of Monet and Renoir—but don't use primary colors and don't, whatever you do, paint outside. That seems to have been the philosophy of the leading British Impressionist, who took the French artists' ideas back home but tended to develop them using newspaper and magazine photos rather than real views.

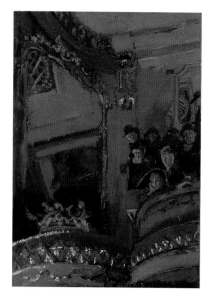

Walter Richard Sickert, *Old Bedford Music Hall* (1894–5): his choice of subject followed Degas rather than the landscape Impressionists.

Not for *Walter Richard SICKERT* (1860–1942) the feel of the wind on your face as you paint, or the sharp smells of the countryside. It was Degas he met first, on a visit to Paris in 1885, and the influence was quickly apparent. Sickert devoted his enormous skills to painting London music halls and their audiences as well as the more disreputable corners of

Venice and Dieppe, where he lived for some years. This was probably why an amateur sleuth named him as one of the many suspects in the Jack the Ripper murders.

The year after Sickert's crucial meeting with Degas, the Impressionist-leaning artists of London got together and formed the New English Art Club. Founder members included *George CLAUSEN* (1852–1944), *John Singer SARGENT* (1856–1925), and *Wilson STEER* (1860–1942). The Club still exists today but at the beginning of the 20th century it was torn apart by feuds between the main factions within Impressionism in London— Sickert's Camden Town Group (who were followers of Cézanne) and the London Group led by *Harold GILMAN* (1876–1919) (who were followers of Van Gogh).

1910 A London doctor claims that if lunacy continues to increase at the present rate, the sane will be outnumbered by the insane within forty years.

1928 The Thames River bursts its banks causing widespread flooding in London, four people drown.

1942 On British radio, a new programme called "Desert Island Discs" asks celebrities to select the music they would take with them to a desert island.

The Impressionists had hoped that Whistler (*see page 38*) would make England safe for Impressionism, but he was much too self-obsessed to do any such thing and when Steer went to a big retrospective exhibition about Manet in 1884, he had to admit he'd never heard of him before. It was left to Sickert and his friends to bring the Impressionist ideas across the English Channel.

But what they brought owed more to Degas than to Monet. The British admired the Impressionists, but they didn't really like them: "One cannot help feeling that some Impressionist work is, in spite of its beauty, disgusting and violent," said one of

NAMES IN THE FRAME

Wilson Steer, *a founder member of the New English Art Club, became one of the most successful British Impressionist painters after studying in Paris from 1882 to 1883. He was particularly influenced by Monet and continued the French Impressionist tradition of painting landscapes rather than lowlife. Check out his* Sands of Boulogne *(1892) and* Children Paddling, Walberswick *(1889–94).*

the founders of the New English Art Club. The British wanted their art rooted in tradition, so the art of Degas suited their more conservative taste.

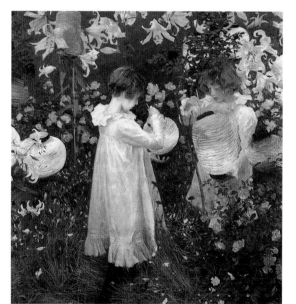

Sargent

Monet's friend John Singer Sargent, the great American-born portrait painter (he completed two portraits of Monet at work), did as much as anyone to bring Impressionist ideas to Britain. Have a look at his amazing *Carnation, Lily, Lily, Rose* (1885–6), which captures the sense of twilight and was painted during two autumns when he worked outside in ten-minute bursts while the light lasted.

John Singer Sargent, *Carnation, Lily, Lily, Rose* (1885–6): Anglo-American Impressionism? Now in the Tate Gallery, London.

1886 Daniel Hudson Burnham and John Wellborn Root build the Rookery building in Chicago, with steel beams and cast-iron columns.

1886 Steve Brodie is found in the water under the Brooklyn Bridge and claims to have jumped off it. New Yorkers are suspicious, since all previous jumpers have perished.

1886 The Kellogg brothers are developing their grain and fruit diet at Battle Creek Sanatorium in Michigan.

1886

Manifesto in Paint
Seurat's Sunday Afternoon

Have the people in Seurat's A Sunday Afternoon on the Island of La Grande Jatte *(1884–6) been frozen stiff? Why do they all stand staring fixedly ahead? Have they been lobotomized? No, the answer is that this isn't supposed to be a momentary impression of a Sunday out, in the old Impressionist style; it's supposed to be a monumental portrait of modern life, with no Classical mythology at all. And because it's made up almost entirely of tiny spots of primary colors, it was recognized immediately as a Neo-Impressionist manifesto.*

Georges Seurat, *A Sunday Afternoon on the Island of La Grande Jatte* (1884–6). It was instrumental in setting the Neo-Impressionist manifesto.

The painting created a stir at the final Impressionist exhibition in 1886. The Impressionists realized Seurat was trying to paint a portrait of modern society—every class is represented—but they also read it as a direct challenge to their idea of instinctive individual responses. Seurat was trying to start a new kind of science.

Not everybody liked it: "One would think the patrons of a café-concert had entered into the house of God," wrote one critic. But there was also enormous excitement about it. Seurat wasn't even 27, but disciples were already flocking to him (*see* box). They loved the way his colors and shade were so powerful, and the way that every figure was vital to the picture. And, most of all, they loved the way that

1886 Britain annexes upper Burma in the Far East after the third Anglo-Burmese war.

1886 French novelist Pierre Loti's influential novel about love and death in Iceland, *Pêcheur d'Islande*, is published.

1886 Around the world, maps and charts are being redrawn to take account of the Greenwich Meridian adopted two years previously.

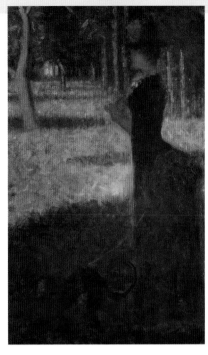

Georges Seurat, a sketch for the finished *Sunday Afternoon* painting. Very un-Impressionist behavior.

Independence

Seurat never really acknowledged his followers, but most were members of the Société des Artistes Indépendants. This grew out of the organization formed in 1884 to show paintings rejected by the Salon, including Seurat's *Bathers at Asnières* (*see page* 92). The opening was marred by fights between members of the executive committee, a number of whom were arrested by the police for assault. Signac was president until 1934, when he was succeeded by Maximilien Luce.

mood. He sketched the figures over and over, took them back to his studio and worked the whole thing up laboriously. Impressionism would never be the same again, and the original Impressionists were only too well aware of it. They had always wanted to develop their art —but not like that.

Seurat was taking art back to strong lines and perspective, forcing figures to fit patterns—just as it was in the good old days of the Renaissance.

It was a return to the ideas of complementary color propagated by Chevreul (*see page 22*). He said that paintings should be "a veritable abstraction of the sum of the moments making up the duration of the occurrence of the scene he has chosen"—and that's exactly what Seurat was trying to achieve. This was no haphazard attempt to capture a fleeting

NAMES IN THE FRAME

Led by his faithful friend and fellow Neo-Impressionist **Signac** (*see page 92*), **Seurat** *suddenly had to contend with whole armies of admirers who claimed him as their leader. These included the artistic police chief* **Albert Dubois-Pillet** (*1846–90*), *the crayon artist* **Charles Angrand** (*1854–1926*) *and the anarchist* **Maximilien Luce** (*1858–1941*), *who was given to painting trainloads of refugees.*

1886 British champion jockey Fred Archer shoots himself at his house near Newmarket, England.

1886 Bloomingdale's opens in New York specializing in whalebone for corsets, yard goods, ladies' notions, and hoop skirts.

1887 There are severe blizzards across the American Great Plains with one storm lasting for 72 hours, and families are found frozen to death inside their cabins.

1886~1890

Lend Me Your Ear
Van Gogh

A special present for a friend.

It's extraordinary that any artist could be in the forefront of painting for less than five years, could spend a large chunk of that time in an asylum, and yet still be one of the most famous painters in history. And as well as all that, now command higher prices at auction than any other artist. But then it was partly the insanity of Vincent VAN GOGH (1853–90), and his amazing ability to transform that inner torment into colors and brushstrokes, that makes him so compelling today. He is still one of art's most romantic figures.

It didn't seem nearly as romantic at the time. Van Gogh was a failed cleric, the son of a Dutch pastor, who plunged himself into Belgian industrial towns as a lay preacher before deciding to give it all up and find salvation—for himself and the miners—in painting.

You couldn't describe Van Gogh as an Impressionist, but he is part of the story of Impressionism. He studied art in Antwerp, arrived in Paris in 1886, met the Impressionist masters and discovered their

TECHNIQUES
The techniques used in Van Gogh's *Starry Night* (1890) exude violence: the backgrounds are painted on with a trowel, with parallel waving lines across the whole canvas. Van Gogh was deeply religious and this was a deliberately religious painting, trying to communicate feelings deep in the soul of everyone. See also another of his last paintings, *Wheat Field with Crows* (1890), whose bleak despair seems like a mirror image of the artist's mental state.

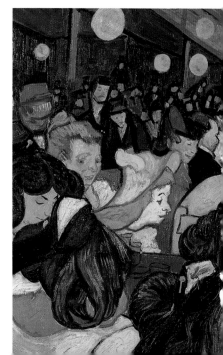

Vincent Van Gogh, *Dance Hall In Arles* (1888): painted using solid blocks of color, and reintroducing black.

1888 English explorer Richard Burton's translations of *The Arabian Nights* are extremely popular but his wife burns all his manuscripts after his death two years later.

1889 William Gray patents the coin-operated telephone. All local calls in the US will cost 5 cents until 1951.

1890 American journalist Nellie Bly travels around the Earth in 72 days, 6 hours, 11 minutes and 14 seconds.

work for the first time. He spent two years learning everything he could from them—the start of an accelerating drive through every painting school he could find.

He devoured Japanese prints and the novels of Zola, and was inspired by them to reintroduce black and white into his paintings after their exile during his Impressionist phase. Next he was assimilating pointillism, then in Provence sucking up Cézanne's influence, then by 1888 he was in Arles trying to found his own community of artists and begging Gauguin to come and join him.

NAMES IN THE FRAME

Van Gogh's long-suffering brother **Theo** *(1857–91)—who had his own destructive breakdown after Vincent's death—was his link to the Impressionists in Paris. Theo was manager of a branch of art dealers in Montmartre, who had begun dealing in Impressionist paintings in the late 1870s despite opposition from his employers. He kept the letters he received from Vincent and they were published in 1959, shedding light on Vincent's mental state as well as what he was trying to achieve in his work. "It sounds rather crude," Vincent wrote, "but it is perfectly true that the feeling for reality is more important than the feeling for pictures."*

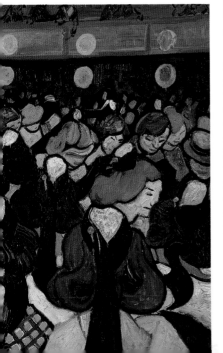

He did, and it was one of the most famously disastrous meetings in art history. Two months after Gauguin's arrival, on Christmas Eve, they had a violent quarrel that ended with Van Gogh cutting off his own ear and giving it to a local prostitute. It was downhill all the way from there, first to the asylum in St. Remy-de-Provence near Arles, until he shot himself in a field near the home of the Impressionists' medical adviser, the engraver and psychiatrist *Dr. Paul GACHET* (1828–1909).

But if Van Gogh's mental state was going downhill rapidly, his artistic progress was accelerating even faster than before in a manic whirlwind. His tortured landscapes and brilliant colors were like nothing that had ever been seen before.

1886 German inventor Paul Gottlieb Nipkov is an early pioneer of television with his rotating scanning device.

1890 Cracker baker F.L. Sommer's Premium Saltines are marketed with a parrot trademark and the slogan "Polly wants a cracker."

1893 English farmer's wife Beatrix Potter writes *The Tale of Peter Rabbit* to entertain a sick child.

1886~1920

International Dabs
Impressionism goes worldwide

By the end of the 1880s, the world was beating a path to the doors of the Impressionists as enthusiastically as if they were the inventors of a more efficient mousetrap. Critics and academics will argue forever about whether Impressionism was a phenomenon that began in Paris and spread outward or something that happened by coincidence around the planet. But there was no two ways about the result: as the 19th century drew to a close, artists all over the world were working out of doors on everyday pictures of modern life painted freely in bright primary colors.

Color bar

What was the most important achievement of the Impressionists worldwide? According to some critics, it was setting artists free to use bright colors. According to the critic Christian Brinton, Paris was "the spot whence radiated this new gospel, (from) there sprang over the face of Europe, and also in America, countless apostles of light, who soon changed the complexion of modern painting from black and brown to blonde, mauve and violet."

Artists like Sargent (*see page* 106). Cassatt (*see page* 80), and Sickert (*see page* 106) had carried the news from Paris to the English-speaking world, but the public in most other cities didn't really engage with Impressionism until Durand-Ruel started taking exhibitions abroad. It was his

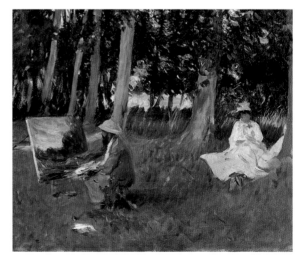

John Singer Sargent, *Monet Painting at the Edge of a Wood* (c. 1887). The two friends spread the movement worldwide.

1904 *The Christ of the Andes is erected on the Chilean-Argentine border. It is more than 29ft (9m) high made from the bronze of old Argentinian cannons.*

1910 Montenegro declares itself an independent Balkan kingdom and Nicholas I becomes king.

1920 Thousands of Bostonians lose their life savings when they are duped by the "Ponzi scheme" which promises a 50 percent return on their investment in 45 days and a 100 percent return in 90 days.

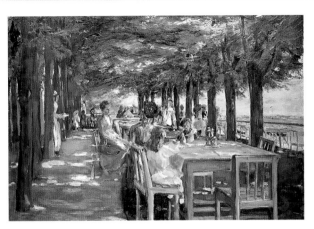

Max Liebermann, *Terrace at the Restaurant Jacob in Nienstedten on the Elbe* (1902–3): German Impressionism.

In Italy, the so-called Macchiaioli group—called that because of their dabs and patches (*macchia* means "patch")—had already developed something a little like Impressionism without any reference to Monet and his friends. But generally speaking, it was Monet's influence in the final years of the century that drove the explosion of the Impressionist idea around the world—just at the same time as the Post-Impressionists (*see page 108*) and Symbolists (*see page 100*) were erupting too. It was a thrilling time to be an artist.

"Impressionists of Paris" exhibition in New York in 1886 that introduced the idea to America—and soon American artists like Theodore Robinson (*see* box) were making the pilgrimage to France to learn all about it for themselves.

The critics didn't like it much. One described Renoir as the "degenerated and debased pupil of so wholesome, honest and well-inspired a man as Gleyre." But Impressionism was there to stay: the punitive American tax system meant that Durand-Ruel soon had to open a permanent branch in the US.

Swedish artists like Karl Nordstrom (1855–1923), Norwegian artists like Harriet Backer (1845–1932) or Christian Krohg (1852–1925) made the same trip, as did Ramon Casas (1886–1932) from Spain and Max Liebermann (1847–1935) from Germany. And so did Seiki Kuroda (1866–1924) from Japan.

> **NAMES IN THE FRAME**
>
> **Theodore Robinson** *(1852–96) was inspired to leave the US and travel to France in 1887, after Durand-Ruel's exhibition. He became a close friend of Monet's, staying in and around Giverny for five years or so. His most important influence on French Impressionism was instilling in Monet his own infectious enthusiasm for the camera. See Robinson's Scene at Giverny (1890).*

1887~1914

Stage Blood

Chekhov and Impressionist drama

By the end of the 19th century, Impressionism had become the dominant creative idea of the age. Within a decade or so, the public had managed to contain their rage at the first appearance of Impressionist paintings. They had even started to admire them; some actually bought them. But similar ideas had seeped into other arts, like poetry, novels (see page 70), and drama, and these provided endless new opportunities to be shocked, if people were so inclined.

August Strindberg, author of *The Dance of Death* (1901): was he a dramatic Impressionist?

If artists could decide not to give their pictures the complete finish that the conservative critics demanded, if they could junk narrative in favor of fleeting impressions and moods, and communicate reality as dispassionate, objective individuals—then so could writers. And so could playwrights.

Impressionist plays arrived in Paris thanks to the actor and producer *André* ANTOINE (1858–1943), who linked up with Zola (*see page 70*) to found Théâtre Libre ("free theater") and to produce what they called "naturalistic" plays, rather than the carefully written moral extravaganzas generally on offer at the time. That meant new plays by *August STRINDBERG* (1849–1912)—who was on his way to Paris for a serious nervous breakdown— and *Anton CHEKHOV* (1860–1904).

NAMES IN THE FRAME

It was all the fault of the Norwegian dramatist **Henrik Ibsen** *(1828–1906), and his emphasis on the duty of every individual to himself. The heroes and heroines of his plays* Ghosts *(1881) and* Hedda Gabler *(1890) have no moral obligations except to themselves and their own creativity. This was reminiscent of the Impressionist painters. And it was the same "life-force" that would soon be popularized by the plays of* **George Bernard Shaw** *(1856–1950). Like the Impressionists, Ibsen put anarchic individualism above everything else.*

1905 Norway becomes independent of Sweden after 91 years of union.

1909 The ballet *Prince Igor* opens in Paris with music by Rimsky-Korsakov and choreography by Diaghilev.

1914 German scientists produce mercury fungicide coatings for seed that will stop plants from succumbing to disease; over the next years it will have disastrous effects on wildlife and human health

Chekhov with the original cast of *The Seagull* (1895), at St. Petersburg's Alexandrinsky Theatre.

Chekhov's first play was produced in Moscow the same year as Théâtre Libre opened its doors in Paris. Soon plays like *The Seagull* (1895), *Uncle Vanya* (1900), and *The Cherry Orchard* (1904) would be putting some of the techniques of Monet and Degas into dramatic form right across Europe. Just like the Impressionists, Chekhov preferred a series of moods and ideas rather than a clear narrative or climax. Just like Degas, his scenes seem to be cut off in the middle like a frame: some of the most important action happens offstage. Just as Monet's pictures were an interaction between colors rather than a complete composition, Chekhov's plays were subtle interactions between characters rather than plot.

The narrative was so subtle in these modern masterpieces that declaiming the words like an orator—in the way actors were supposed to speak at the time—just made them incomprehensible. Chekhov and Strindberg required a whole new kind of acting. And just as the Impressionists changed art forever, however much the public might sneer at the new drama, time was on their side.

Critics

A "deplorably dull play handled by a bungler," wrote London's leading theater critic after watching Ibsen's *Ghosts* for the first time. "An open drain, a loathsome sore unbandaged, a dirty act done publicly." And it was said of Strindberg that he had "searched for God and found the Devil."

1891 In Liverpool the first street collection for charity takes place, in aid of Lifeboat Day.

1893 A fountain called *Eros* is erected in London's Piccadilly Circus in memorial to Lord Shaftesbury, although the subject is at odds with his puritanical reputation.

1895 27-year-old Irishwoman Bridget Clary is burned to death for witchcraft in County Tipperary.

1889~1901

Bill Stickers

Toulouse-Lautrec

Toulouse-Lautrec at his favorite place.

What was it about those Post-Impressionist artists that drove them on so disastrously, till they either burst forth briefly like Van Gogh or destroyed themselves from the inside like Gauguin? Whatever it was, something about the determination to turn Impressionism into a whole new way of creating art seems to have been on the unhealthy side for its proponents.

Take the aristocratic artist *Henri Marie Raymond de TOULOUSE-LAUTREC* (1864–1901), for example. He broke both legs as a child, stunting his growth for the rest of his life, which was an unfortunate beginning. His interest in art separated him from his family and sent him into a ceaseless haunting of the dance halls and brothels of Montmartre to provide material for his trademark paintings. By 1899 he was in a clinic recuperating from the effects of alcoholism, but he never fully recovered and died of a stroke two years later at the age of just 36.

Debauchery

Toulouse-Lautrec knew how to shock. High art wasn't for him: he illustrated restaurant menus and he famously received the puritanical Durand-Ruel (*see page 66*) while surrounded by women from the brothel of the rue des Moulins. He had great sympathy for the harshness of the prostitutes' lives, as can be seen in paintings like *In Bed* (1893), but that didn't stop him sleeping with them when he felt like it.

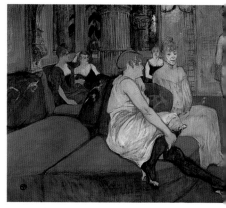

Henri Toulouse-Lautrec, *In the Salon, rue des Moulins* (1894): his sympathetic study of prostitutes chatting as they patiently wait their turn.

He built up a style in that brief career that was completely his own, starting as an Impressionist, but assimilating everything around him: Van Gogh's paintings (*see page 114*), Japanese prints (*see page 34*).

1896 The hymn "When the Saints Go Marching In" is written by James Black with lyrics by Katherine Purvis.

1898 French designer Louis Vuitton produces canvas luggage with his initials branded on them to try and prevent piracy.

1901 Norwgian artist Edvard Munch paints *Girls on the Bridge*.

Henri Toulouse-Lautrec, *Mademoiselle Lender* (1895): his pictures had a wild, frenetic energy and were painted increasingly freely.

Gauguin, and Bernard (*see page* 100). His style owed more to Degas than to anyone else, but it wasn't light that fascinated him, like the true Impressionists; it was finding the right line, something that could sum up the gesture and movement of a whole scene.

Toulouse-Lautrec was welcome everywhere because he made people laugh, and he would sit on the same seats or crouch in the corner scribbling on whatever piece of paper came to hand, studying the scene for weeks sometimes before actually starting a painting. The finished pictures range from the calm anticipation of prostitutes waiting their turn in *In the Salon, rue des Moulins* (1894) to the frenetic energy of *Mademoiselle Lender* (1895).

It was a style that coincided

with the first great age of advertising, and Toulouse-Lautrec was soon using his slabs of color to create posters. It was "high season of the poster art," borrowing from Japanese prints and the Arts and Crafts Movement in England and Art Nouveau in France (*see page* 124), and nearly always including a great swirling woman to draw the eye into the heart of the picture.

TECHNIQUES

The basis of lithography—the technique for printing posters—is that grease and water don't mix. If the artist draws his pictures with a greasy crayon and the whole thing is made wet, then the ink sticks to the greasy part but not to the wet surface. If you then press this "stone" to paper, the ink transfers on to it.

NAMES IN THE FRAME

*The man most responsible for the development of poster art was a friend of Monet and Degas called **Jules Chéret** (1836–1932), who invented the polychrome lithography process and whose posters first inspired Toulouse-Lautrec. After Toulouse-Lautrec, it was the great poster artist and caricaturist **Leonetto Cappiello** (1875–1942), whose FrouFrou (1899) took his technique into the next century.*

Did it count as art? People who were looking for refined avant-garde pictures that nobody else could understand were irritated by the whole idea, but Toulouse-Lautrec clearly felt otherwise.

1890 Milk has to be pasteurized by law in the US but there is strong opposition from people who consider it unnatural.

1891 Basketball is invented inSpringfield, Massachusetts by physical education teacher James Naismith to occupy students between the football and baseball seasons.

1892 The first omnibus strikes cause consternation and bad temper in London.

1890~1894

Looking for a Cathedral in a Haystack
Monet's serial paintings

Monet was becoming as grumpy as Cézanne, but there was no doubt about it—he was suddenly a success. He was also subtly changing his style. Maybe it was because of a new ideological thought: if it was the instantaneous moment of light you were trying to capture, it might help to paint the same scene over and over again. Of course, the pictures were the same but different—and the public loved them anyway.

> **TECHNIQUES**
> Sitting in his suite at the Savoy Hotel in London, or occasionally on the other side of the Thames at St. Thomas's Hospital, Monet would surround himself with a hundred or so unfinished canvases. Then he would search through them frenetically, choose one that looked a little like the scene in front of him, and modify it completely. When he had finished everything that he wanted to do with a particular scene, he always made sure that the remaining unfinished works were destroyed.

The story goes that Monet first hit on the idea of a series of paintings as he tried to capture the changing light on the haystacks behind his house at Giverny in 1890. Every time the light changed, he asked his wife to bring him out another canvas. By the end of the following year, there were 25 finished paintings of the haystacks, in different seasons, lights and weather conditions. They were a kind of manifesto of what Impressionism should be all about, and when Durand-Ruel (*see page* 66) exhibited 15 of them in May 1891, it was Monet's most successful exhibition to date.

He followed it up with a series called *Poplars on the Epte* (1891) and then from 1892 the famous series of paintings of the front of Rouen Cathedral, in every kind of

1892 Anarchist idealists commit violent outrages across Paris.

1893 Toulouse-Lautrec produces a color poster for the Divan Japonais, a Paris café where the waitresses wear kimonos.

1894 Rudyard Kipling's *Jungle Book* features Mowgli, Balloo, and Shere Khan.

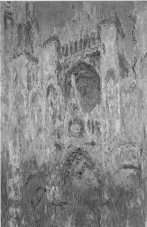

Claude Monet, *Cathedral of Rouen; Effect of Light: End of the Day* (1892): one of his early Rouen pictures.

light and weather—rather close up, which led to criticisms that there was not enough sky or ground. This time he painted from the window of the shop opposite so he didn't have to stand outside in all weathers watching the light change, as he had with the haystacks. It was a little like Pissarro's similar move (*see page 98*).

The next series was of the Thames River, begun in 1899 when his son went to London to study English. Monet painted from the fifth floor balcony of his room in the Savoy Hotel and by 1904, he had over 100 paintings of the same bridges and the same buildings in Westminster. "Without the fog, London would not be a beautiful city," he said. One wonders what he would have made of the same fogless scene today.

"I am chasing a dream," said Monet on his trip to Norway in 1895, in the middle of working on these series. "I want the unobtainable. Other artists paint a bridge, a house, a boat, and that's the end. They're finished. I want to paint the air which surrounds the bridge, the house, the boat, the beauty of the air in which these objects are located, and that is nothing short of impossible."

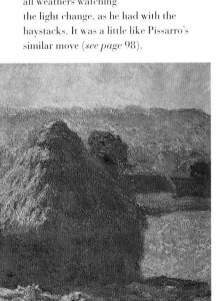

Claude Monet, *Grain Stacks, End of Summer* (1891): it was the effects of light on the haystacks that first gave Monet the idea.

The Cathedral

Durand-Ruel's Monet exhibition in 1895 was the first time the Rouen Cathedral pictures were seen together, and they were originally priced at 12,000 francs each. It was another enormous success. Monet had "made the stones themselves live," said the future French wartime leader, his friend Georges Clemenceau (*see page 128*).

1895 Work begins on London's Westminster Cathedral, the last great building in Britain to be made of brick without steel reinforcements.

1898 The headline screeches "J'Accuse" when Emile Zola writes an open letter to the press in support of the falsely imprisoned Captain Dreyfus.

1914 General Joseph Galliéni doesn't have transportation to get his soldiers to the Battle of the Marne so he requisitions 600 Paris taxis and packs ten men into each.

1890~1947

The Second Generation
Bonnard and Vuillard

While the next generation were first tinkering around with their paints, it was the thrilling and miserable Post-Impressionists who were hogging the limelight. The next generation of Impressionist painters had to find their way back to Impressionism—and the trademark fascination with light—via all the exciting new byways of Symbolism, primitivism and poster art.

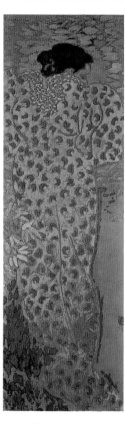

Pierre Bonnard, *The Dressing Gown* (1892): more about pattern than impression.

That was how *Pierre BONNARD* (1867–1947) started. He cofounded the Nabis group with Serusier and Denis but failed to win a major art prize, so he settled down to life designing posters—until his *France-Champagne* (1891) suddenly got noticed by Toulouse-Lautrec (*see page 118*). By 1890, he was sharing a studio with Denis (*see box*) and his friend and collaborator *Édouard VUILLARD* (1868–1940).

All three were inspired by the usual trio—Degas, Gauguin, and Japanese prints—and their studio became the main meeting place for the Nabis artists, an unusual crowd dedicated to rediscovering spirituality in pictures until they all broke up in confusion in 1899.

NAMES IN THE FRAME

Other artists in the same generation took a different route. After his encounter with Signac (see page 92) in St-Tropez in 1903, the former lawyer **Henri Matisse** *(1869–1954) helped transform Neo-Impressionism into a new movement, based around brilliant colors and high emotion, which became known as Les Fauves ("the wild beasts"). See for example his portrait of his wife,* Green Stripe *(1905). In this way, Impressionism seemed to lead inexorably into the nonrealistic art of the 20th century.*

1919 André Breton collaborates with Philippe Soupault on *Les Champs Magnétiques*, an experiment in Surrealist automatic writing.

1923 Scientist Gaston Ramon develops a vaccine for tetanus at France's Pasteur Institute.

1942 French crews scuttle most of their fleet at Toulon to prevent it from falling into the hands of the Germans.

Together, Bonnard and Vuillard concentrated on everyday scenes, sometimes indoors, sometimes in the street. The subjects were completely overwhelmed not so much by light, as in an old-fashioned Impressionist picture, but by color, pattern and texture, as if the wallpaper had entirely taken over the room. Check out, for example, Vuillard's *The Piano* (1896). Or have a look at Bonnard's tall, thin, Japanese-style oils *The Four Seasons* (1891).

While Denis stayed with the inspiration of Renaissance religious artists like Fra Angelico, his studio colleagues found themselves developing a new kind of

Theater
The new generation was fascinated by the theater. Bonnard and Sérusier (*see page 108*) produced the decor for the revolutionary play *Ubu Roi* (1896) by the Symbolist and Surrealist Alfred Jarry (1873–1907). The Nabis also kept a puppet theater at the studio of Paul Ranson (1864–1909) in the boulevard Montparnasse, which they nicknamed "The Temple." The Académie Ranson attracted Bonnard, Denis and Sérusier to teach after Ranson's death.

personal, indoor Impressionist style, which became known as *Intimisme*. By 1900, Intimisme was in full throttle but it was a different kind of Impressionism from the one pioneered by Monet and Renoir. It was more like Sickert (*see page* 106) or Cassatt (*see page* 80), with their quiet rooms and domestic family scenes—a couple of people bathing or sunlight through the window. It wasn't quite as majestic as the front of Rouen Cathedral, but it was still Impressionism.

Pierre Bonnard, *The Breakfast Room* (date unknown): intimate and indoor narrative, but was still judged to be impressionistic.

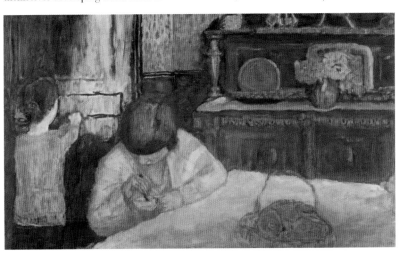

1895 The first Venice Biennale is held, showcasing international art.

1896 An expedition led by Jean-Baptiste Marchand sets out to claim the Sudan for France.

1897 A London taxi-driver, George Smith, becomes the first Briton to be arrested for drunk driving.

1893~1910

Fin de Siècle

Art Nouveau and the Aesthetes

It was the so-called Naughty Nineties in England, as tired-looking British aristocrats made the long journey to Paris for passion, art, and something enjoyably disreputable. The objectivity of the Impressionists had developed among their followers into a whole new attitude of world-weary cynicism, a hatred of anything except urban life and a search for truth by rejecting bourgeois society.

How Aubrey Beardsley saw himself. Background: a sensual drawing for *Salomé*.

Poor old Oscar Wilde (*see page 38*) was an Aesthete to the end (last words: "This wallpaper is killing me. One of us must go"). But before completely giving up the ghost, Wilde and other leading Aesthetes found themselves doing a complete and unexpected *volte face* by embracing the Roman Catholic Church.

The key figure was the shocking young dandy *Aubrey BEARDSLEY* (1872–98), who died of tuberculosis at only 26, but whose black-and-white prints—some of them scandalously erotic—created a whole new style of illustration. He was a major influence on the decorative style known as Art Nouveau—a mixture of Japanese

Gaiety

Unsurprisingly, it was Degas who held the Aesthetes in most contempt. In fact, he saw no difference at all between Aestheticism and homosexuality: if you affected "taste," according to Degas, it meant you probably slept with other men. He met Wilde just before his imprisonment. "You know how well-known you are in England," said Wilde, to which Degas replied: "Fortunately, less so than you."

prints, Celtic symbolism and Arts and Craft foliage—through the new magazine *The Studio* (1893). He went on to illustrate Wilde's shocking *Salomé* (1894), and drove the Art Nouveau movement by editing the magazine *The Yellow Book* (1895), before he was completely shunned by polite society after Wilde's arrest.

Art Nouveau appeared everywhere, from the new Paris Métro entrances (1898–1901) to the chairs and staircases of the Scottish architect *Charles Rennie MACKINTOSH* (1868–1928); from the glassware of the American designer *Louis*

1899 There is a riot in a cinema in Paris after a woman sits on the arm of her seat because she can't see the screen and police intervene to remove her.

1900 A survey reveals that only one in seven US homes has a bathtub.

1901 The first soluble instant coffee is sold in Buffalo at the Pan-American Exposition.

Comfort TIFFANY (1848–1933) to the interior of the fashionable Paris restaurant Maxim's. The style was known as "Youth Style" in Germany, "Secession Style" in Austria, and "Liberty Style" in Italy, after the London department store that specialized in Art Nouveau fabric designs.

It was all rather a long way from Impressionism, but that is where the roots of Art Nouveau lay—with the absolute objectivity of the artist, the uniqueness of every moment and every individual and the slightly snobbish attitude to ordinary taste that seemed to follow from it.

We still have Art Nouveau with us today, but without all the ideological clutter.

Tiffany's lamps (1912), showing the enormous influence of Art Nouveau on contemporary designers.

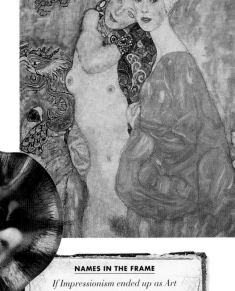

Gustave Klimt, *Girlfriends* (1916–17). Art Nouveau paintings could sometimes seem like high camp. Klimt used gold and precious metals in his patterns.

NAMES IN THE FRAME

If Impressionism ended up as Art Nouveau, where did Art Nouveau end? It has stayed amazingly popular, but its most extreme proponents were probably the Austrian artist **Gustav Klimt** *(1862–1918), with his golden Symbolist paintings, and the Spanish architect* **Antoni Gaudí** *(1852–1926), whose fantastical architecture you can see in Barcelona Cathedral, looking as modern and unusual as it did then.*

1895 *The Time Machine* by H.G. Wells is set in the year 802701 and tells of a society divided into subterranean workers called Morlocks and decadent elite called Eloi.

1900 At Stonehenge, the megalithic monument on Salisbury Plain, England, stone number 22 and its lintel fall down.

1902 London's Metropolitan Police obtain their first conviction based on fingerprint evidence, against one Harry Jackson.

1895~1914

The Movies

Edison, Lumière and motion pictures

Let's face it: what Monet was striving toward in his series of paintings of the same subject seen in changing light was the movies. He didn't have long to wait. The Grand Café at the boulevard des Capucines—scene of some of the first Impressionist exhibitions—was soon the venue for the first showing of the first proper film, Quitting Time at the Lumière Factory. *It was 1895, and the cinema audience flinched in terror at the famous shot of a train racing toward them.*

Georges Méliès, *A Trip to the Moon* (1902).

The American inventor *Thomas Alva Edison* (1847–1931) had been developing the Kinetoscope in his tar shack in West Orange, New Jersey. And in France, *Louis Lumière* (1862–1954) and his brother *Auguste* (1864–1948) had developed the far more practical Cinématographe. Unfortunately, they didn't understand what they had done: "Cinema is an invention without a future," they said before going off to try something else.

It was the French magician *Georges Méliès* (1861–1938) who developed the idea into a medium that could tell stories, interpret life and even be a work of art. His film *A Trip to the Moon* (1902) is credited with being the first to use special effects, after he found that—by stopping in mid-shot and moving things around—he could make them seem to appear and disappear.

Monet already possessed four cameras and was pressing them into service with pictures of Rouen Cathedral and his other series. Degas had been particularly

Telling a story

The first proper movie "story" came from Edison's studio in the US. Called *The Great Train Robbery* (1903), it was only eight minutes long. It included the first intercutting of scenes from shots taken at different times and the first screen chase. It was also an enormous success, leading to the emergence of small nickelodeons all across the US.

1905 Alexander Scriabin writes *The Divine Poem,* Symphony No. 3 in C minor in the same year as he abandons his Russian wife and four children to run off with his Swiss mistress.

1908 Hans Geiger and Ernest Rutherford develop the geiger counter to detect radioactivity.

1914 Charlie Chaplin appears as an amorous cad in *Making a Living;* the movie involves a mix-up in a lady's bedroom and a grand finale on the cowcatcher of a moving train.

fascinated by the work of Eadweard Muybridge (*see page* 90) and loved his 1887 book *Animal Locomotion*, containing over 100,000 photos of horses, animals and naked humans walking and running. This massive resource later proved very useful to Degas when he was painting his own pictures of horses.

The problem with the movies was that the action was all too fast. It was snapshots and frozen moments in time that had influenced the Impressionists. Although they may have been striving for a sense of momentary light and the way it changes over time, once cinema had done it for them—and without the genius of individual interpretation—it was somehow a signal that Impressionism had little else to teach. You didn't have to pretend to be completely objective with the movies, because the camera really was objective. Cinema was a genuine mass medium. It was, once again, time for art to move on.

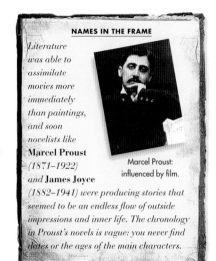

NAMES IN THE FRAME

Literature was able to assimilate movies more immediately than paintings, and soon novelists like **Marcel Proust** *(1871–1922) and* **James Joyce** *(1882–1941) were producing stories that seemed to be an endless flow of outside impressions and inner life. The chronology in Proust's novels is vague: you never find dates or the ages of the main characters.*

Marcel Proust: influenced by film.

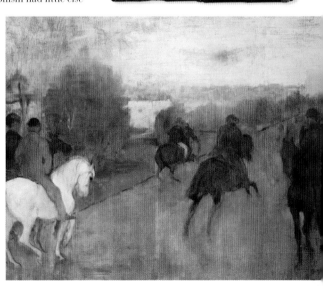

Edgar Degas, *Riders on the Road* (1861–8). Degas became increasingly fascinated by the idea of painting horses on the move and he often frequented the local racetrack.

1900 The trademark "His Master's Voice" appears on gramophone records along with a picture of a fox terrier called Nipper listening to a horn gramophone.

1903 The state of Florida acquires the rights to the Everglade swamp. Drainage will begin in 1906.

1905 At a Royal Command performance of G.B. Shaw's *John Bull's Other Island*, Edward VII laughs so hard that he breaks his chair.

1899~1926

Wet and Blue
The Waterlilies

Throughout the last quarter century of his life, Monet became obsessed with something that was right under his nose—the waterlily pond at his home in Giverny. All those swirling greens and blues seemed to be the epitome of what Impressionism was all about. By the end of his life, he had transferred the idea to a series of monumental paintings, which he was determined to present to the French nation.

Work in progress
The panels were a gigantic project, so big that Monet had to build a new studio in his garden that would be big enough to house them. Marc Elder's book *A Giverny chez Monet* (1924) describes his "strong, angry, flustered hand" and the pile of half-finished canvases in the corner which Monet instructed his servants to burn.

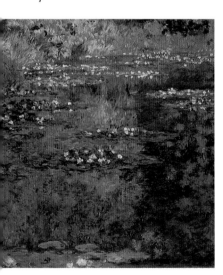

Claude Monet, *The Waterlily Pool* (1904): the edge of the picture cuts off the sky. The subject was secondary; his main interest was always in the effects that could be achieved with color.

to look at, but it's madness to want to paint it. Oh well, I'm always getting into such things."

But once in, this time he never came out. He painted the waterlilies at dawn, at dusk, in sunlight, and usually from eye-level, but with his usual Impressionist motif: the picture frame cuts off the sky. That isn't so of his really famous *Waterlilies* (1899), with its other Impressionist trademark of a Japanese-style bridge—though the sky is obscured by the trees. But it is so of his *Waterlily Pool* (1904), with its floating red and yellow flowers on glassy green water.

The idea of painting his own pond struck Monet the moment he moved to Giverny in 1890. "I have again taken up something impossible—water with grass rippling at the bottom," he wrote that year, in his usual self-dramatizing style. "It's fine

1906 Pavlov's dogs dribble when a bell is rung even if there is no food on offer.

1916 A proliferation of the plankton *Gymnodium brevi* causes a "red tide" in Florida and kills millions of fish.

1926 Slide fasteners get the name "zips" after a demonstration at which English novelist Gilbert Frankau says "Zip, It's open! Zip, it's closed!"

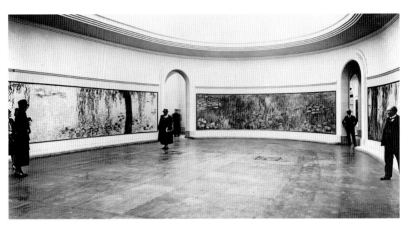

Encouraged by his friend, the wartime French leader *Georges CLEMENCEAU* (1841–1929), a former mayor of Montmartre and author of several books of art criticism. Monet spent the First World War and the years afterward creating a cyclorama of 12 gigantic, 13ft (4m) long panels based on his water gardens. Again encouraged by Clemenceau, he planned to present them to the nation. There were one or two little conditions: they had to be displayed at their best and the French government had to buy his painting *Women in the Garden* (*see page* 28).

You can now see the works in the Orangerie at the Tuileries in Paris. The agreement was signed in 1922, though the display didn't actually open to the public until 1927 and Monet carried on poking around in there for the rest of his life. If people had been shocked because the early Impressionist paintings looking unfinished,

The exhibition of Monet's Nymphéas panels in Paris in 1930, four years after the artist's death: they were very popular but this must have been a quiet day.

it was nothing compared to the sketchy splashes that made up Monet's Nymphéas panels, which were more like abstract art than his early pictures (*see page* 132). But by this time Monet was honored as a French national treasure and, after more than half a century of Impressionist painting, the public taste had changed enough for them to be appreciative.

Setback

Clemenceau had been the one who agreed the deal with Monet, so the whole project received something of a setback when he lost the French election of 1920. But after considerable confusion, the new government paid Monet the substantial sum of 200,000 francs for *Women in the Garden* (a hundred times more than the price he got for his earliest pictures) and finally agreed to adapt the rooms at the Orangerie to suit the pictures.

1899 A 26-year-old secretary called Alice Guy-Blaché becomes head of production at Gaumont Film Company in France.

1901 The Belgian future Nobel Prize winner Maurice Maeterlinck writes the philosophical treatise, *The Life of the Bee.*

1913 Alain-Fournier's modern classic novel *Les Grands Meaulnes* is published. He was inspired to write it by his love for a tall blonde girl he saw in June 1905.

1899~1926
Fog, Nudes and Lily pads
Old Impressionists

There were a number of events in the year 1899 that suddenly showed the Impressionists they were getting older. It wasn't just that Renoir was being treated for rheumatism, or that Toulouse-Lautrec was an alcoholic, or that Monet had come down with serious flu on his trip painting the Thames. It was also that Sisley died of throat cancer that year: "as great a master as any who have ever lived," said Monet.

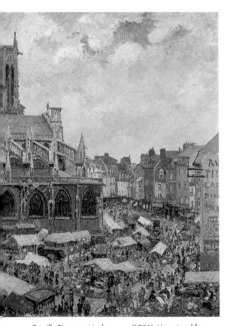

Camille Pissarro, *Market Surrounding the Church of Saint Jacques, Dieppe* (1901). He painted from his window, trying to catch the everyday bustle.

Circumstances had changed for all the remaining Impressionist pioneers as they entered their 60s. For one thing they were successful and the histories of art were beginning to recognize them. Their pictures were in museums and were fetching high prices. Even so, Pissarro managed to find himself an anonymous studio under the arches of the fish market in Dieppe in his search for examples of ordinary life to portray.

But as they disappeared into old age, they tended to become more extreme. The anit-semitic Degas became almost incoherent with rage about the Dreyfus Affair (*see page* 71). Monet's paintings became increasingly abstract (*see page* 132). Renoir's nudes (*see page* 94) became even more deliberately reminiscent of French traditional paintings. At the same time, Renoir was spending a great deal of time with the new avant-garde in the person of Matisse, while Degas found himself admiring the work of Gauguin.

1919 George Gershwin writes "Swanee" and Al Jolson will record it the following year.

1922 Ludwig Mies van der Rohe introduces ribbon windows to his design for an office building; they are strips of glass divided by vertical concrete slabs.

1926 Al Capone's Chicago headquarters are sprayed with machine gun fire from men in eight passing cars but no one is killed.

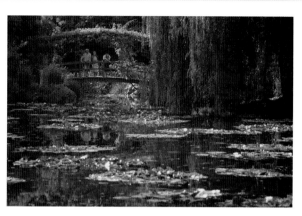

A waterlily pond in Monet's garden at Giverny, which is now open to the public.

Bronzed

Both Degas and Renoir turned to sculpture in their final years. Degas finished about 70 wax models before his death, only one of which was cast into bronze during his lifetime. But Renoir's were slightly different, because he didn't actually execute them himself. He hired the sculptor Richard Guino (1890–1975) to work under his direction, but Guino stormed out after a disagreement in 1917.

Many Impressionist artists went blind. Maybe it was all that intense focusing on the light, but Degas, Monet, Renoir, Pissarro and Cassatt could hardly see their own paintbrushes toward the end of their lives. Bizarrely, some had declaimed earlier in life that they would like to become blind so as to see the world in different ways. Monet carried on painting when he could

NAMES IN THE FRAME

The fatal year for Impressionism was 1903, with the deaths of **Toulouse-Lautrec, Gauguin** *and* **Pissarro**. *Like some of his friends, Pissarro died blind, but he also left behind him a dynasty of family painters to carry on the craft. There was his son* **Lucien** *(see page 36), who settled in England in 1890 and founded the Eragny Press, becoming an influential printer, and his granddaughter* **Orovida** *(1893–1968), who was also a painter.*

barely see. Renoir continued until he could barely hold a brush and had to have them strapped to his hands: "Seated he is a frightful spectacle, elbows clamped to his sides, forearms raised," wrote one critic who visited him in 1918. "He was shaking two sinister stumps dangling with threads and very narrow ribbons. His fingers are cut almost to the quick; the bones jut out, with barely any skin on them."

Monet lived for another seven years after Renoir, in his house at Giverny, which is now preserved for the nation. When he died in 1926, Clemenceau (*see page 128*) dashed there from Paris and arrived as the coffin was being removed under a black cloth. Knowing that Monet had spent his life spurning the color from his palette, Clemenceau tore it off in protest.

1900 King Umberto I of Italy is shot and killed by an anarchist, Angelo Bresci.

1907 The L'Oréal perfume and beauty empire is founded in France by chemist Eugene Schueller.

1909 The first kibbutz is started in the Jordan Valley in Palestine.

1900~1926

Leaving Out the Scene
Abstract Impressionism

What you see is not always what you get.

There's an inherent contradiction in Impressionism, and you feel like sitting them down and demanding an answer to it. If the artists were just an implacable objective eye, painting what they saw without interpretation or moralizing, then how come they were such outrageous individualists? Of course they were interpreting what they saw. They had to be—otherwise there wouldn't have been a picture.

The early psychologist *William James* (1842–1910) imagined what it would be like for newborn babies experiencing all five senses for the first time. He called it "blooming, buzzing confusion." Maybe it was because Monet was pushing his technique to its logical conclusion; maybe it was because he was losing his sight—but blooming, buzzing confusion was exactly what he had begun to paint.

The result became known as Abstract Impressionism or, alternatively, Abstract Expressionism, which means much the same thing. It was a bit like automatic painting, with splashes of color here and there. One critic defined it as "Retaining the quiet uniform pattern of strokes that spread over the canvas without climax or

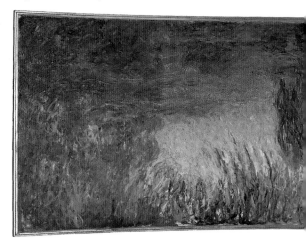

Claude Monet, *Nymphéas: The Setting Sun* (1916–26). It's stunning, but would you know what was in the picture if you hadn't read the title?

1911 Henri Matisse paints *The Red Studio* and *The Blue Window*.

1917 Clarence Birdseye returns to New York after three years spent in Labrador doing experiments on food freezing; he has learned, among other things, how to freeze cabbages in barrels of seawater.

1920 The Bloody Mary cocktail is invented at Harry's Bar in Paris.

emphasis, these followers keep the Impressionist manner of looking at a scene but leave out the scene." It was, in other words, Impressionism without the picture.

You can see the result in some of Monet's vast canvases of waterlilies—like *Nymphéas: The Setting Sun* (1916–26)—or in the paintings of Leicester Square he

> **NAMES IN THE FRAME**
>
> *Maybe it was all the fault of Monet's friend the poet* **Mallarmé** *(see page 70), one of the main influences on the Aesthetic Movement in France toward the end of the century. Via his well known Tuesday evenings at his home, he spread the gospel that Impressionism was too precise: all we can do is evoke and suggest, he said. Monet did as he suggested.*

dashed off on visits to London. You can see the same thing in some of Van Gogh's late works—such as his *Fourteenth of July in Paris* (1886–8). Did Monet invent abstract or Surrealist art? Well, he was trying to paint subconscious ideas, just as the Surrealists would try to do. But Surrealism was already happening well before Monet was splashing on any paint.

Ludwig Gies's *Crucifix*, shown at the 1938 Nazi exhibition with the catchy name "Degenerate Art."

Degenerates
Although early exponents of Surrealism linked their new movement to Communism, on the whole it was exactly the kind of philosophy that the totalitarian leaders of the 20th century disliked and distrusted most. Perhaps it wasn't surprising that works by Cézanne, Van Gogh, and Gauguin were included in a Nazi exhibition in Munich in 1938 with the scathing title of "Degenerate Art."

1902 Hungary's imposing Gothic Houses of Parliament are completed after nine years and stand on the Danube in Budapest.

1905 America's first pizzeria is opened in Spring Street, New York, and called Lombardi's.

1913 Edvard Ericson sculpts *The Little Mermaid* to sit on a rock in Copenhagen.

1900~1945

Relative Penis Envy
Einstein, Freud, and the Impressionist legacy

"Subconscious mind, pah!" Degas would have said about the idea of psychoanalysis—and probably did, because he lived a good 17 years after the publication of Freud's important book, The Interpretation of Dreams *(1900). He wouldn't have taken much to the idea of dreams or relativity or quantum mechanics. Yet those critical 20th-century ideas might not have been possible without the Impressionists.*

> **NAMES IN THE FRAME**
>
> *Impressionism was both a symptom and a cause of what became known in the 20th century as Existentialism, the philosophy based on individual freedom and choice. "I must find a truth that is true for me," wrote the Danish pioneer* **Søren Kierkegaard** *(1813–55), "the idea for which I can live or die." * **Friedrich Nietzsche** *(1844–1900) in the 19th century and* **Jean-Paul Sartre** *(1905–80) in the 20th followed the same path.*

So many of the great ideas of the following century came down to the simple proposition that what you see is not what you get. We think we have a clear idea of our relationships and behavior, but actually we are a mass of forgotten unconscious forces blowing us hither and thither, as the research work of *Sigmund Freud* (1856–1939)—ensconced in his Vienna consulting rooms—was just beginning to demonstrate.

We think we have a clear understanding of the forces of history, and the kings, bishops, and battles that shape it. But actually we are at the mercy of the hidden forces of class warfare, as the work of *Karl Marx* (1818–83)—ensconced in the British

Gaetano Previati, *Maternity* (1891). The next generation of Impressionists was trying to communicate something more philosophical than the transience of beauty through their art.

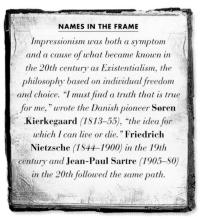

1922 Australia takes steps to protect the koala bear after fur trappers have nearly wiped it out of existence.

1934 Henry Miller's *Tropic of Cancer*, partly describing his erotic adventures in 1930s Paris, is banned in the US soon after publication.

1938 Adolf Hitler annexes Austria then engineers a plebiscite which shows that 99.75 percent of Austrians want union with the Third Reich.

Paul Gauguin, *Maternity* or *Three Women on the Seashore* (1899): another view of the same idea Previati was trying to communicate.

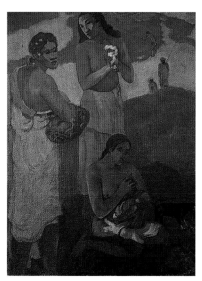

Museum Reading Room—had already demonstrated, at least to those who believed him.

We think we understand how the forces of gravity keep us on the ground and how time passes. But actually we are at the mercy of the vagaries of space-time where everything is relative, as the work of *Albert Einstein* (1879–1955)—ensconced in his Zurich tramcar—was just about to reveal to the world. Worse, the mere presence of a scientist with measuring apparatus in an experiment was liable to skew the result—just like an Impressionist painter.

There is a big gap, in other words, between what we think we see and know and what is actually there. We live in a relative world where all we get are impressions, and where—in quantum mechanics at least—all you can know is the probability that something is true or not.

This was the *Zeitgeist* as the century changed, when every poet was concerned with fleeting moods rather than grand passion, where everything was about symbols and nuance, and where the whole idea of objective truth seemed to have been finally pensioned off.

> **To clarify . . .**
> This is how the critic Arnold Hauser puts it: "The concept of deception . . . that every impression we receive from it is knowledge and illusion at the same time, is an impressionistic idea, and the corresponding Freudian notion that men spend their lives concealed from themselves and others, would have been hardly conceivable before the advent of Impressionism."

1930 The first soccer world cup is won by Uruguay in the year that their country celebrates 100 years of independence.

1940 Bugs Bunny makes his screen debut in *A Wild Hare*, with the catch phrase "Eh, what's up, Doc?"

1957 African killer bees escape from a breeding experiment in Brazil and head north.

1930~2001

Frenzied Auctioneers
The posthumous success of the Impressionists

If the impoverished and insulted Impressionist pioneers had lived until today, they would have been rich beyond their wildest dreams—with their paintings regularly fetching eight-figure sums at auction. They would, of course, have been too old to enjoy it much. Even so, they have undergone an extraordinary transformation, from the pariahs of modern art to the most valuable artists in history.

Two of the last witnesses of the Impressionist era—Morisot's diarist daughter Julie Rouart, née Manet, and Monet's last surviving son Michel—both died in 1966. Renoir's son Jean, the film director, survived until 1979. Manet Jr. donated the house at Giverny to the Académie des Beaux-Arts.

When they died, Impressionism had passed through its establishment phase and was out of favor again. But the last 40 years have seen a burgeoning fascination with Impressionist art, and a similar burgeoning of the pockets of the big dealers as its prices sky-rocketed.

The big league
No matter how much the mainstream Impressionists can command, they are normally out-gunned by Van Gogh. Within months of the record-breaking sale of *Sunflowers* in 1987, the record was broken again with his *Irises* (1889) selling for $53.9 million. The trend continued in 1998 with the sale of his *Self-Portrait with a Clean-Shaven Face* (1889) for $65 million. It's ironic that only one of his paintings was sold during his lifetime.

Vincent Van Gogh, *Sunflowers* (1889). Unsold in the artist's lifetime, it went for a fantastic $24.7 million at auction in 1987.

1977 American poet Robert Lowell writes: "If we see light at the end of the tunnel, It's the light of the oncoming train."

1996 When Sotheby's auction the estate of the late Jacqueline Kennedy Onassis, buyers pay $33,350 for a footstool and $85,000 for a rocking horse.

2000 Robbers attempt to drive a JCB into the Millennium Dome and steal the De Beers Millennium Diamond worth $578 million then make off in speed boats, but they are foiled by undercover police officers dressed as cleaners.

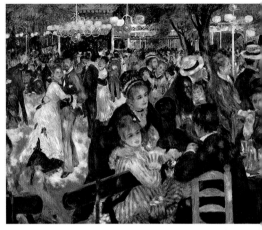

Pierre-Auguste Renoir, *Dancing at the Moulin de al Galette* (1876). This was painted for fun not for money!

It was partly to do with hyper-inflation, which meant the seriously rich needed to find hedges against inflation and tax write-offs. Often they chose pictures. But it was also partly to do with the rapid rise of the yen in the 1980s, and developing interest from the newly wealthy Japanese institutions. By 1985, the Matsuoka Art Museum in Tokyo was splashing out $4 million on Monets, Pissarros and Renoirs. But it was the Yasuda Fire and Marine Insurance Company that turned Impressionist prices on their head.

They caused a sensation in 1987 when they bought the last remaining private version of Van Gogh's *Sunflowers* (1888) at auction for $24.7 million—more than three times the previous world record price for a painting. But that was just the start.

The 1990s were the boom years of Impressionism—and not just for the auctioneers. Major exhibitions in Boston, Chicago, Paris, Philadelphia and London drew large crowds year after year, culminating in the immensely popular "Monet in the 20th Century" exhibition that opened at the Royal Academy in London in 1999. But it was still the auction houses that really cleaned up. Renoir's *Dancing at the Moulin de la Galette* (*see* page 78) fetched the enormous sum of $78.1 million at

NAMES IN THE FRAME

The Nazis represented a major threat to Impressionist art during the war, because they considered it "decadent." Within two months of occupying Paris, the Nazis had confiscated more than 200 paintings from Jewish collectors, many of them Impressionist. Efforts of special Allied art teams to rescue them helped develop the study of art history, culminating in the publication of the crucial History of Impressionism *by John Rewald in 1946. Efforts continue today to trace works of art and return them to the prewar owners.*

Sotheby's in New York in 1990. It was followed in 1993 by Cézanne's *Still Life: Large Apples* (1890-4), which sold for $26 million, and Renoir's *Bather* (1888), which fetched $19 million.

Where to see the Impressionists

In 1874 the only place the artists could find to show their work was in Nadar's former studio, luckily Impressionist Art has become very popular since then, with most museums and art galleries containing a few examples. If you want to travel further afield here's a few ideas...

MUSÉE D'ORSAY, PARIS
Including Degas's *The Absinthe Drinker*, Caillebotte's *The Floor Strippers*, Manet's *Olympia* and *Déjeuner sur L'Herbe*, Monet's *Rouen Cathedral*, *Gare Saint-Lazare*, *Water Lilies*, *Haystacks* and *Women in the Garden*, Renoir's *Dancing at the Moulin de la Galette*, Sisley's *Floods at Port Marly*, Whistler's *Portrait of the Artist's Mother*.

MUSÉE MARMOTTAN, PARIS
Including Monet's own art collection, left by his son Michel in 1966.

MUSÉE RENOIR, CAGNES-SUR-MER
His own home.

MUSÉE CLAUDE MONET, GIVERNY
His own home and possessions.

MUSÉE DE L'ATELIER DE PAUL CÉZANNE
Including his personal possessions.

MUSÉE FABRE, MONTPELLIER
Good collection of Bazille's pictures.

PUSHKIN MUSEUM OF FINE ARTS, MOSCOW
Including Monet's *Boulevard des Capucines* and Pissarro's *Avenue de l'Opera*.

NEUE NATIONALGALERIE
Including Renoir's *Lise and a Gypsy Girl*.

WALLRAF-RICHARTZ MUSEUM, COLOGNE
Including Sisley's *Bridge at Hampton Court*.

NEUE PINAKOTHEK, MUNICH
Including Manet's *Monet Working on his Boat at Argenteuil*.

KUNSTMUSEUM, BASEL
Including Pissarro's *The Gleaners*.

FITZWILLIAM MUSEUM, CAMBRIDGE
Including Monet's *The Poplars*.

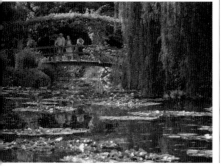

Claude Monet's garden at Giverny, with waterlily ponds, is open to the public.

COURTAULD INSTITUTE, LONDON
Includes Manet's *Bar at the Folies-Bergère*, Renoir's *La Loge*.

NATIONAL GALLERY, LONDON
Including Cezanne's *Bathers*, Degas's *Miss La La at the Cirque Fernando*, fragments of Manet's *Execution of the Emperor Maximilian*, Monet's *The Thames at Westminster*, Pissarro's *Lower Norwood*, Renoir's *Umbrellas* and Seurat's *Bathing at Asnières*.

TATE GALLERY
Including Degas's *Little Dancer*.

MUSEUM OF FINE ARTS, BOSTON
Including pictures from Monet's various series and his *The Japanese Girl*, Renoir's *Dance at Bougival*, Cassatt's *Five O'Clock Tea*.

ART INSTITUTE OF CHICAGO
Including Caillebotte's *Street in Paris*, Cezanne's *Bay of Marseilles* and Seurat's *Sunday Afternoon on the Island of La Grande Jatte*.

CLEVELAND MUSEUM OF ART
Including Renoir's *Three Bathers*.

METROPOLITAN MUSEUM OF ART, NEW YORK
Including Degas's *The Ballet from Robert de Diable*, Monet's *La Grenouillère*, and from his *Poplars* and *Haystacks* series.

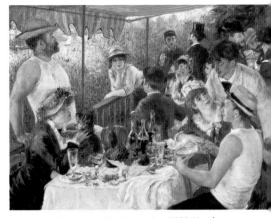

Pierre-Auguste Renoir's *Luncheon of the Boating Party* (1880–1), at the Phillips Collection.

MUSEUM OF MODERN ART, NEW YORK
Including Cézanne's *Still-Life with Apples* and a whole room devoted to Monet's *Waterlilies*.

PHILADELPHIA MUSEUM OF ART
Including Degas's *The Ballet Class*, Monet's *Poplars on the Banks of the Epte* and *The Japanese Footbridge* and the *Waterlily Pond, Giverny*.

NATIONAL GALLERY OF ART, WASHINGTON, DC
Including Manet's *The Toreador*, Pissarro's *Orchard in Bloom, Louveciennes* and Renoir's *Bather Arranging her Hair*.

PHILLIPS COLLECTION, WASHINGTON, DC
Including Renoir's *Luncheon of the Boating Party*.

Glossary of Terms

These crazy artistic movements! As soon as one was established, another emerged from it, and artists jumped between them at will. This is a quick reference to the key movements and terms. Confused? You will be...

ABSTRACT IMPRESSIONISM
Allowing the subconscious to create shapes and colors without worrying too much whether it results in a recognizable picture. Many of Monet's final works are attributed to this genre.

AESTHETIC MOVEMENT
The late-19th-century philosophical and artistic movement that celebrated beauty above all other ideals, following in the footsteps of Beardsley and Wilde.

ART NOUVEAU
The artistic movement of the 1890s that spread across Europe, in which writhing stems and plants were used to decorate flat surfaces.

ARTS AND CRAFTS
The movement in late Victorian Britain that searched for simple, handmade patterns and design, as a reaction against overdecorated Victorian factory products.

AVANT-GARDE
Pioneers and innovators in art or literature.

CHIAROSCURO
Mixture of light and shadow, traditionally hard to portray in a painting.

COMPLEMENTARY COLORS
When two colors combine to complete the spectrum of colors. Red and green are complementary colors, and so are blue and orange, and yellow and violet.

CUBISM
The attempt to portray three dimensions in a two-dimensional picture. This artistic movement developed largely from the work of Cézanne.

DIVISIONISM
Seurat and Signac's preferred term for Pointillism.

EXISTENTIALISM
Philosophy based on individual freedom and human choice, expounded by Jean-Paul Sartre, among others.

EXPRESSIONISM
Deliberately exaggerating or distorting lines and colors to achieve an emotional impact; pioneered by Van Gogh.

FAUVISM
The style produced by a group of artists, including Matisse, known as "Les Fauves" (the wild beasts). Their signature style was the use of flat patterns and violent colors.

INTIMISME
A movement started by the second generation of Impressionists. These artists chose intimate indoor scenes of modern life as their subject matter.

LITHOGRAPHY
Print-making process used to create posters, based on the principle that water will not adhere to oiled surfaces.

MACCHIAIOLI
Italian group of artists who developed a kind of Impressionist style, independently from mainstream Impressionism.

NABIS
Artistic movement, related to Symbolism; the artists used bright colors, often with religious imagery. The name comes from the Hebrew word for "prophets."

NATURALISM
Portraying people and modern life as they really are.

NEO-IMPRESSIONISM
Another word for the Pointillist style pioneered by Seurat, with the term coined by the critic Félix Fénéon.

PALETTE
The surface that artists use for paints and for mixing colors.

POINTILLISM
The technique of applying paint in dots of pure color, which are combined in the eye of the viewer, rather than on the palette.

POST-IMPRESSIONISM
The name given to the variety of revolutionary styles that emerged as a direct result of the influence of Impressionism.

PRIMITIVISM
The artistic movement linked to Symbolism, whereby artists use a simple, childlike approach to painting. The style emerged largely from the work of Gauguin.

ROMANTIC
The influential artistic and intellectual movement that emerged at the end of the 18th century as a reaction against the dry, Classical, unemotional style prevalent during the Enlightenment.

SALON
The official French art exhibition, held every year since 1667. The name is also used to denote the group who chose the exhibited work.

SURREALISM
The idea that artists could be free from conventional ways of portraying reality, which became increasingly associated with the Communist Party.

SYMBOLISM
The art movement in which objects or pictures became symbols that stood for emotional states.

Index